RELAXING PATTERNS

Lori's Pattern Coloring Books for Adults

VOLUME 2

copyright © 2017 Lori Greenberg – All rights reserved.

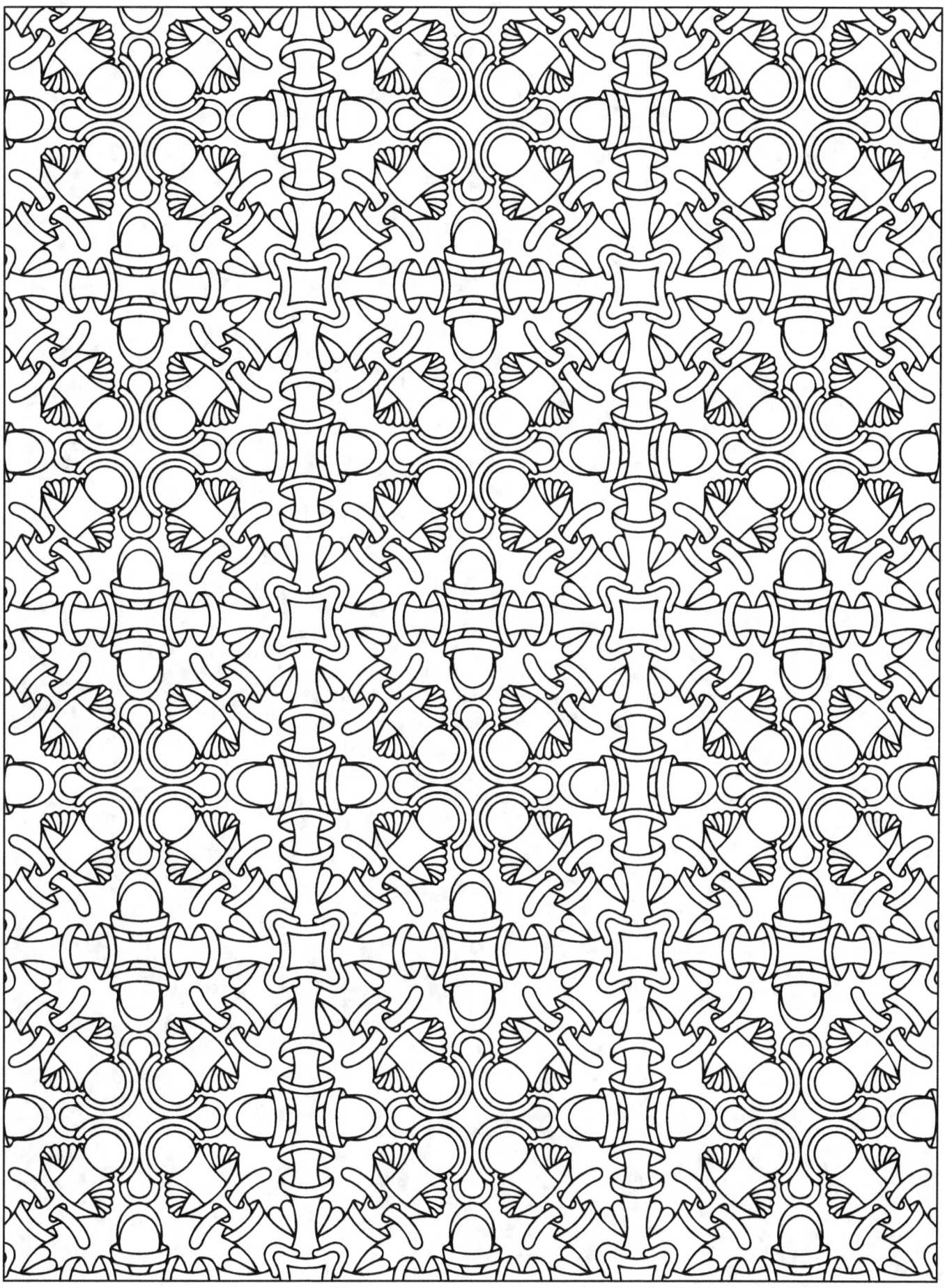

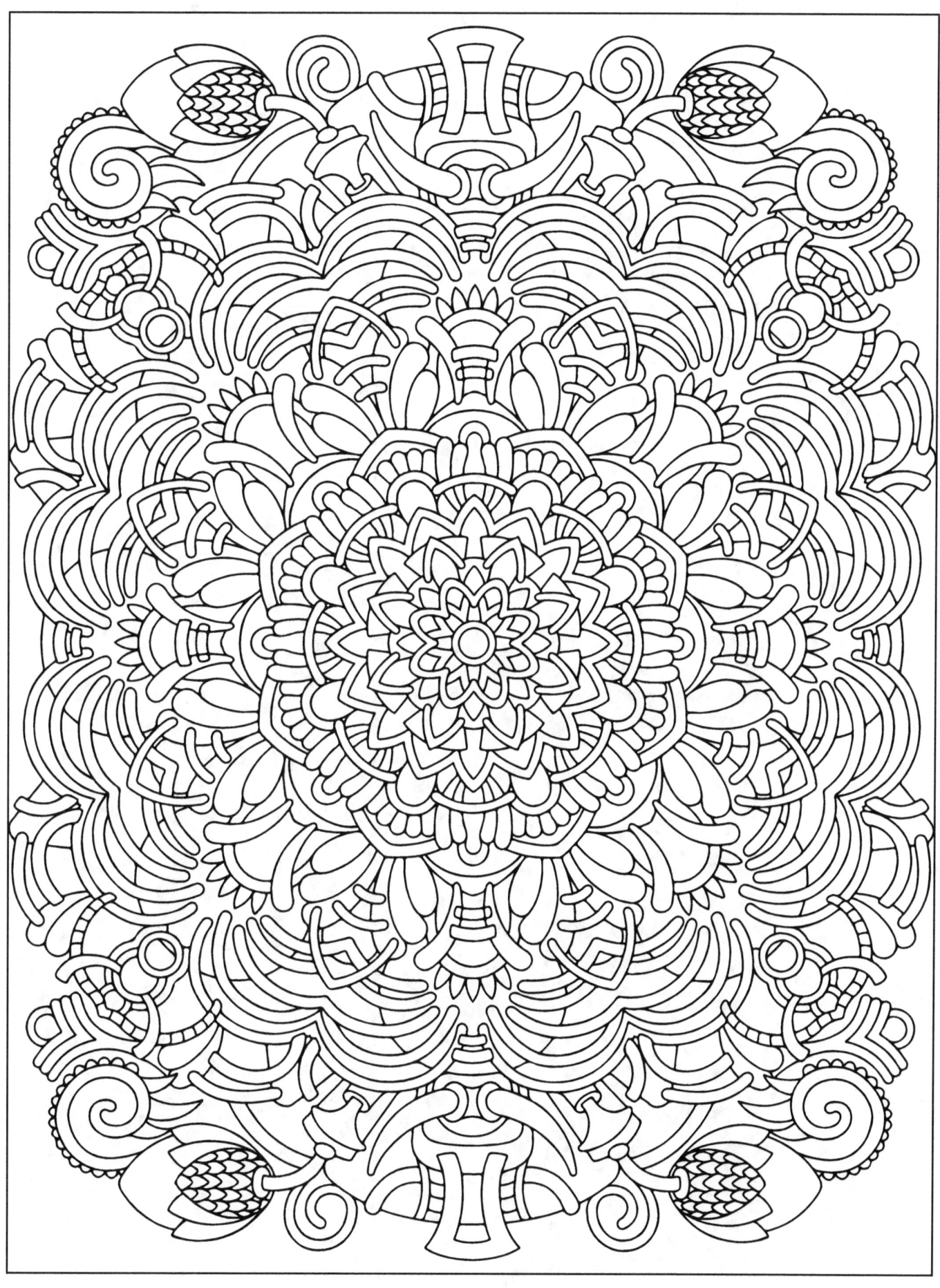

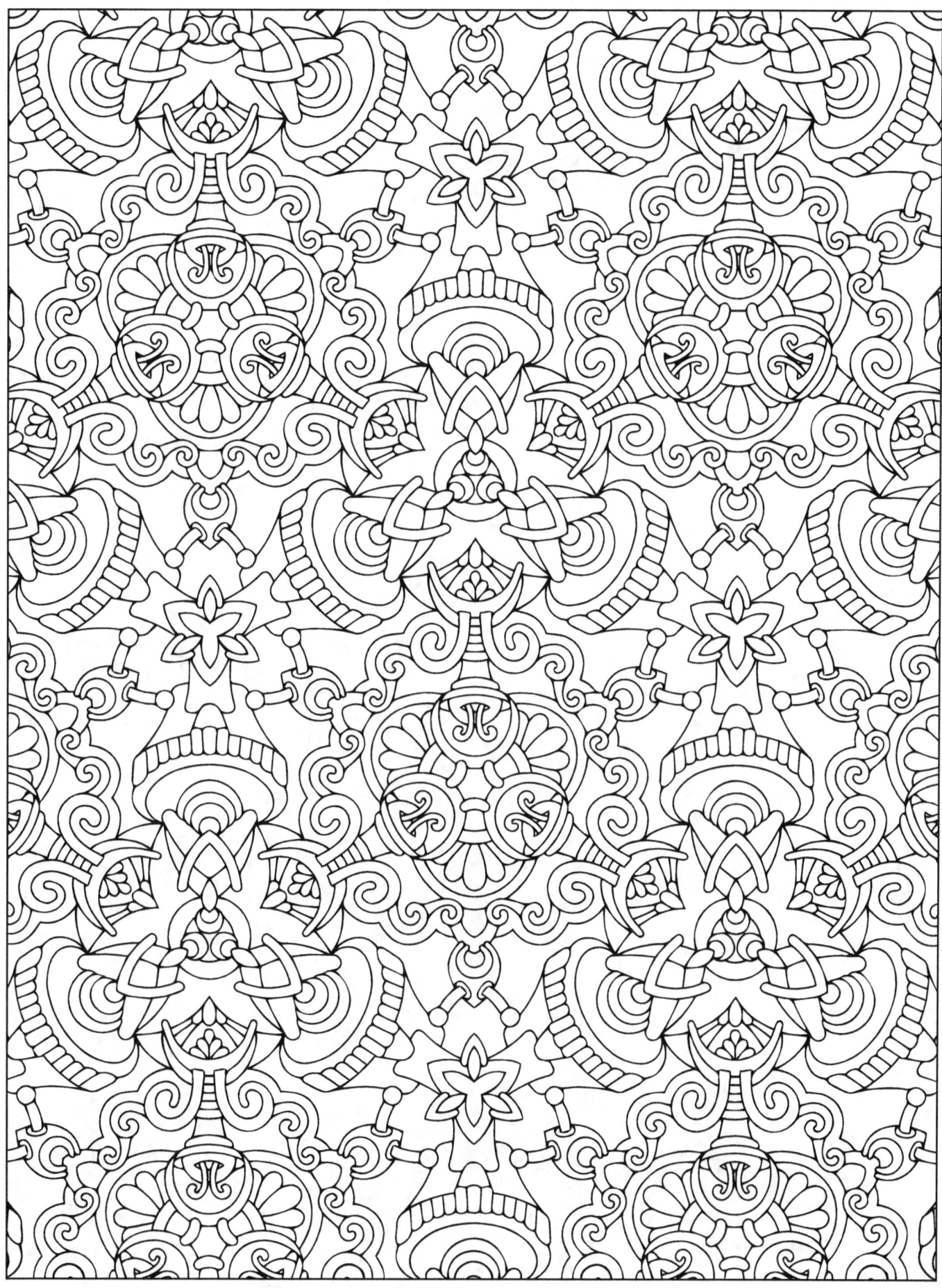

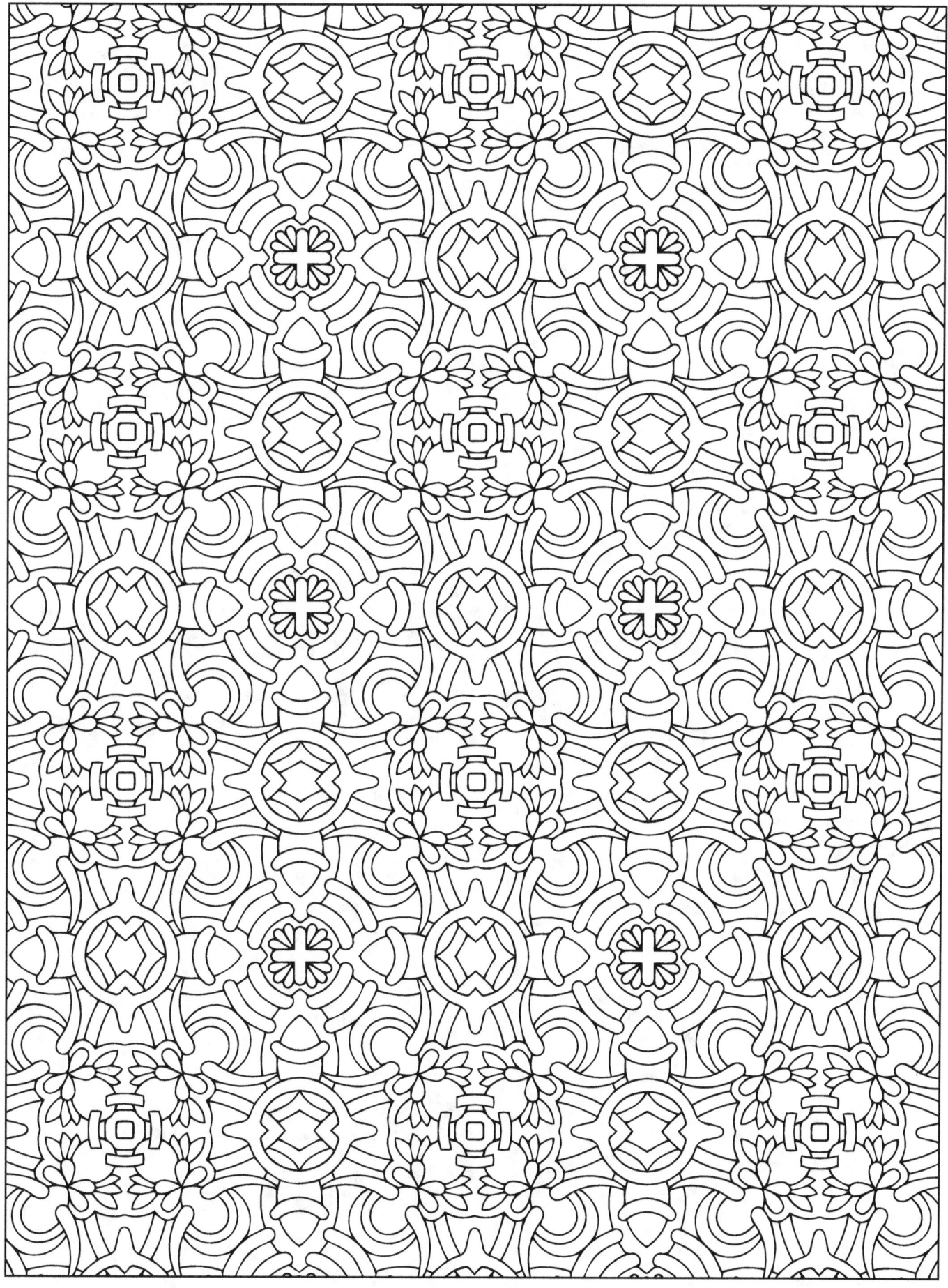

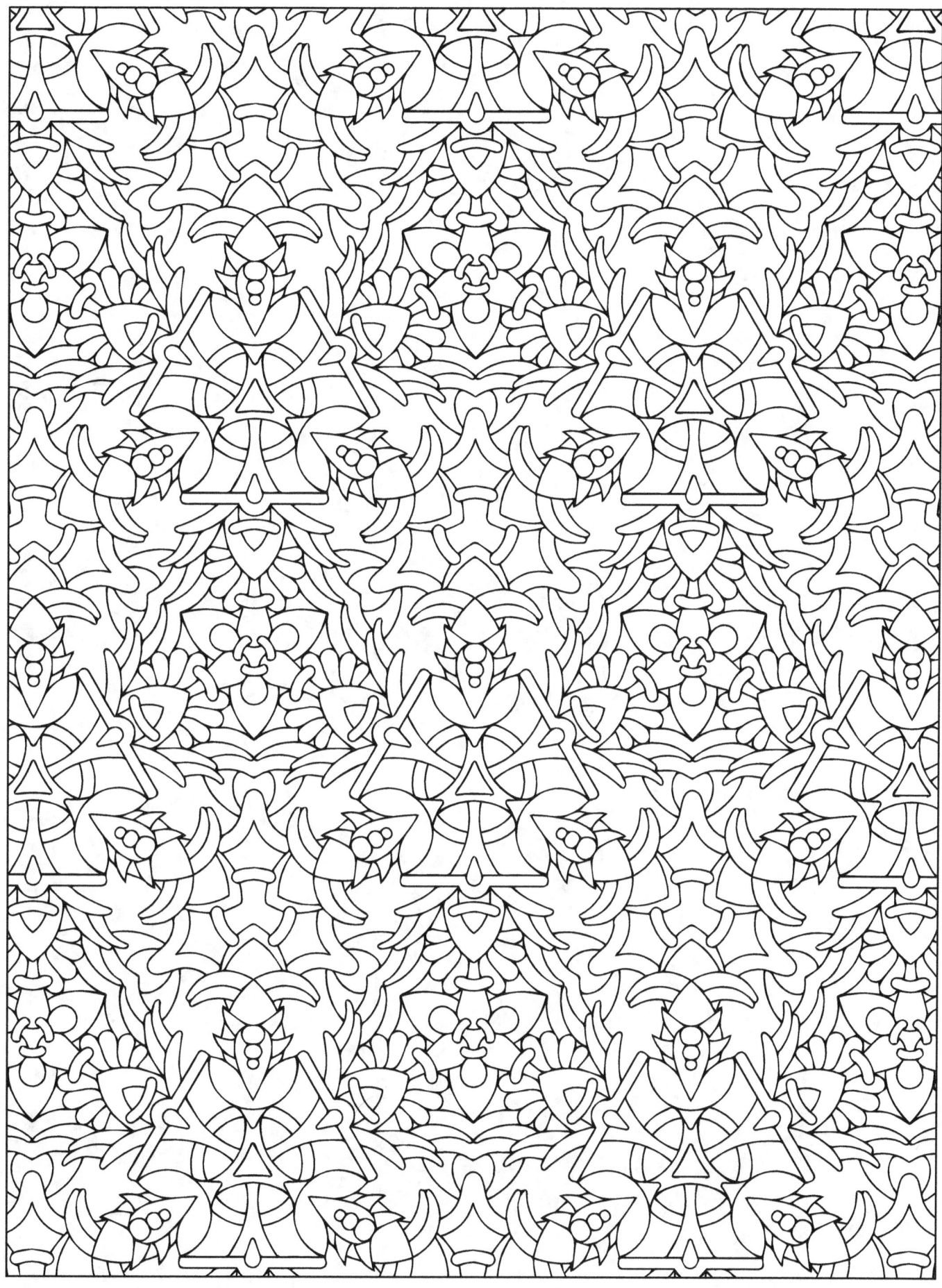

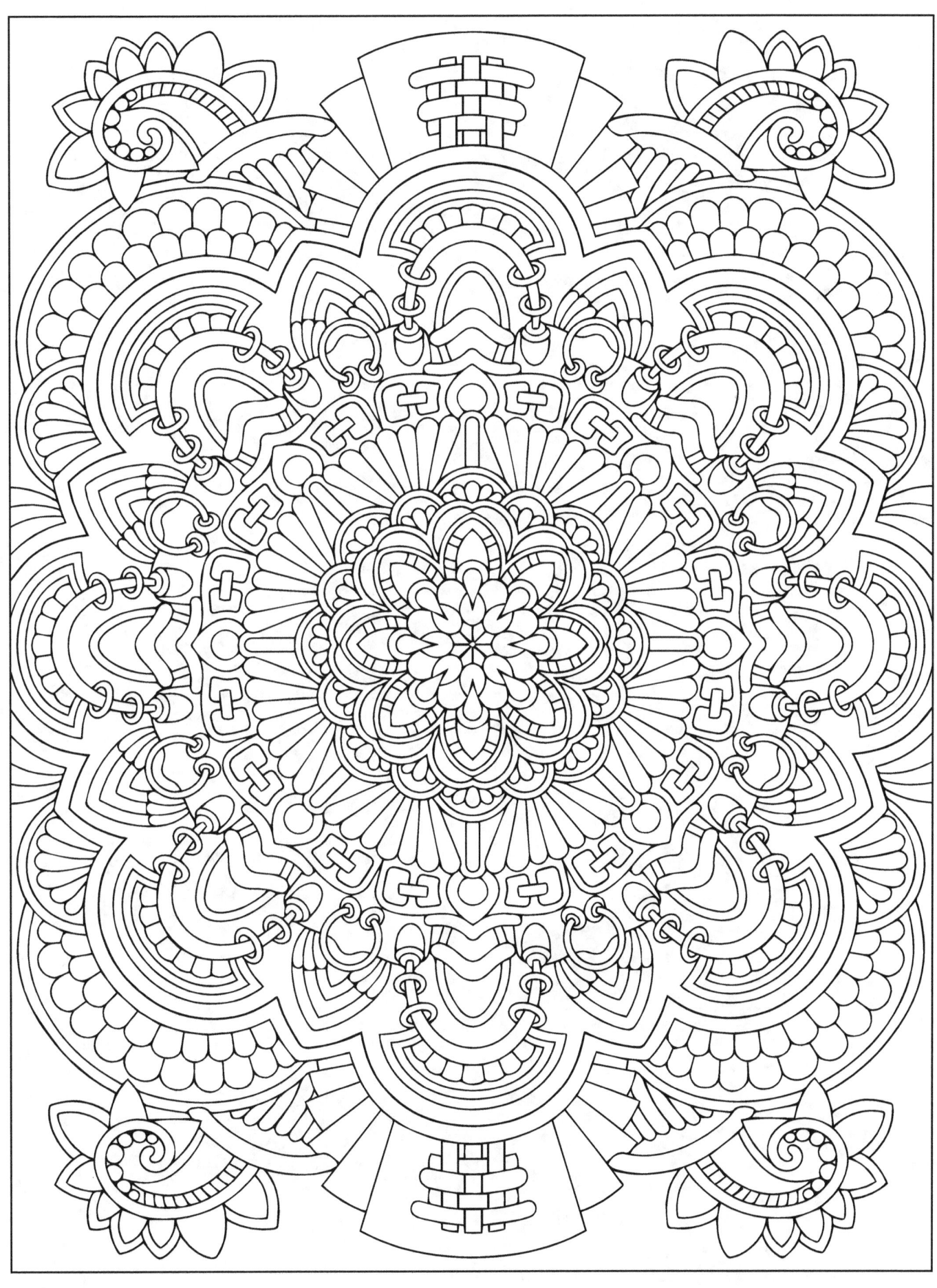

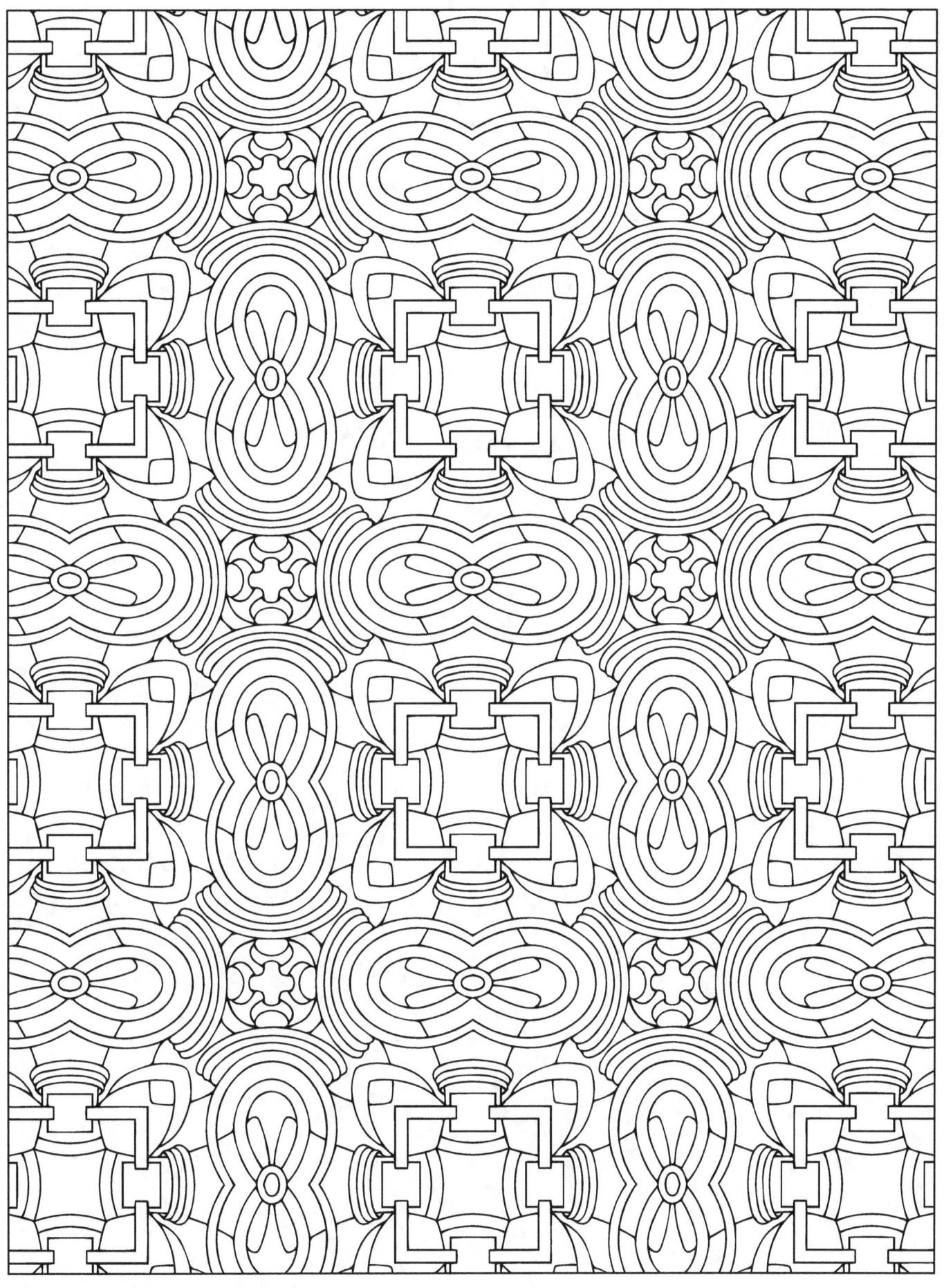

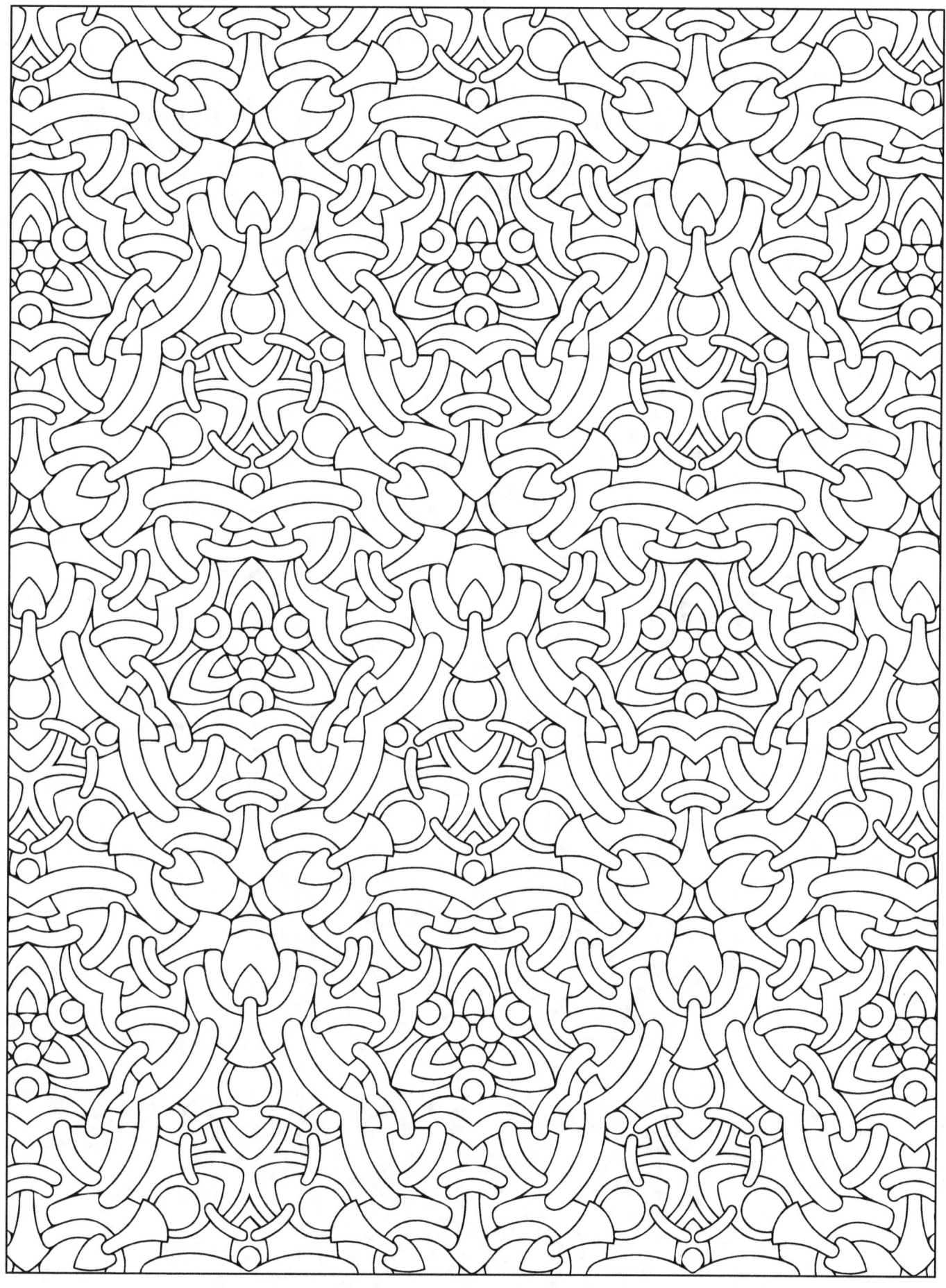

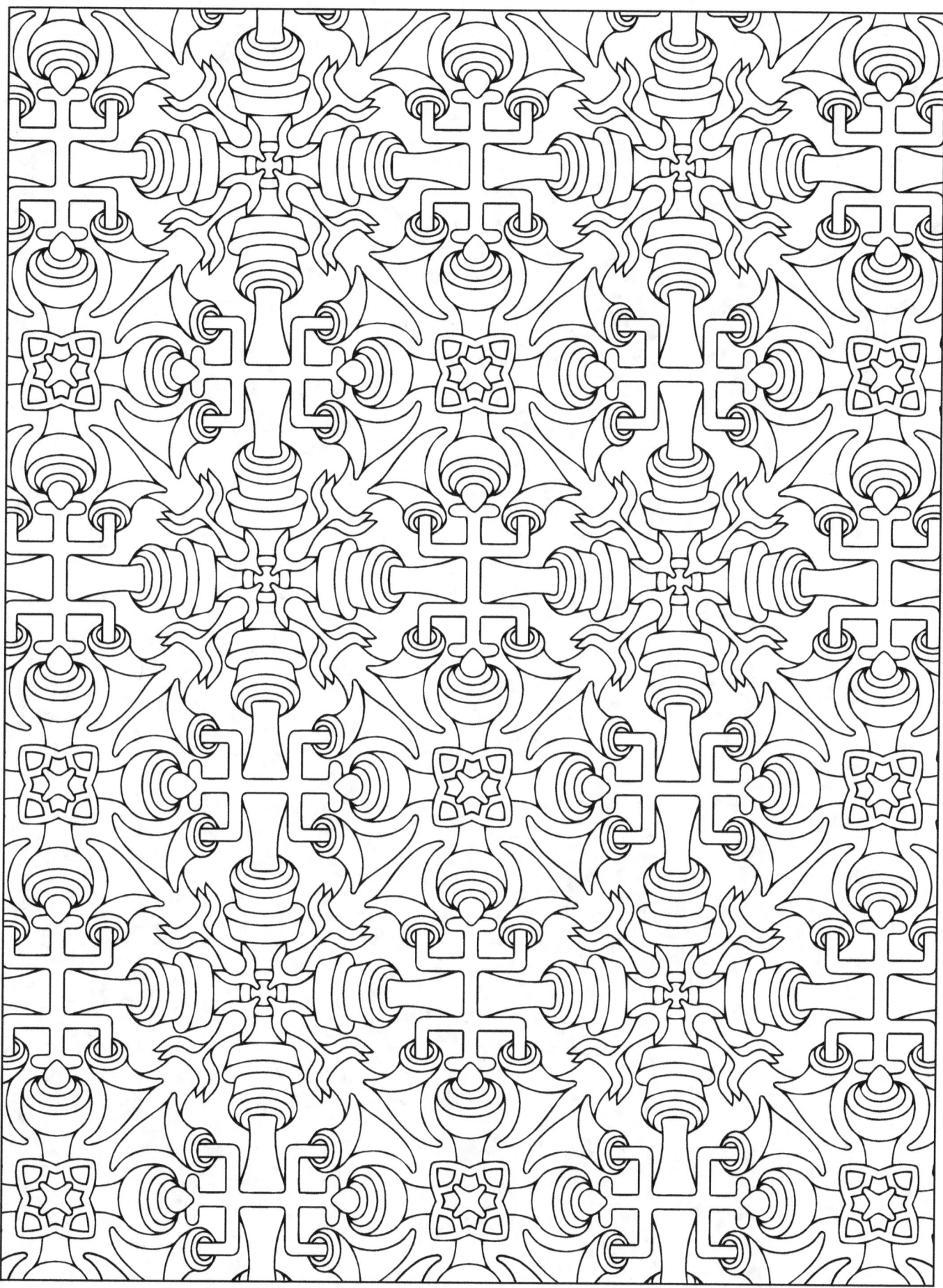

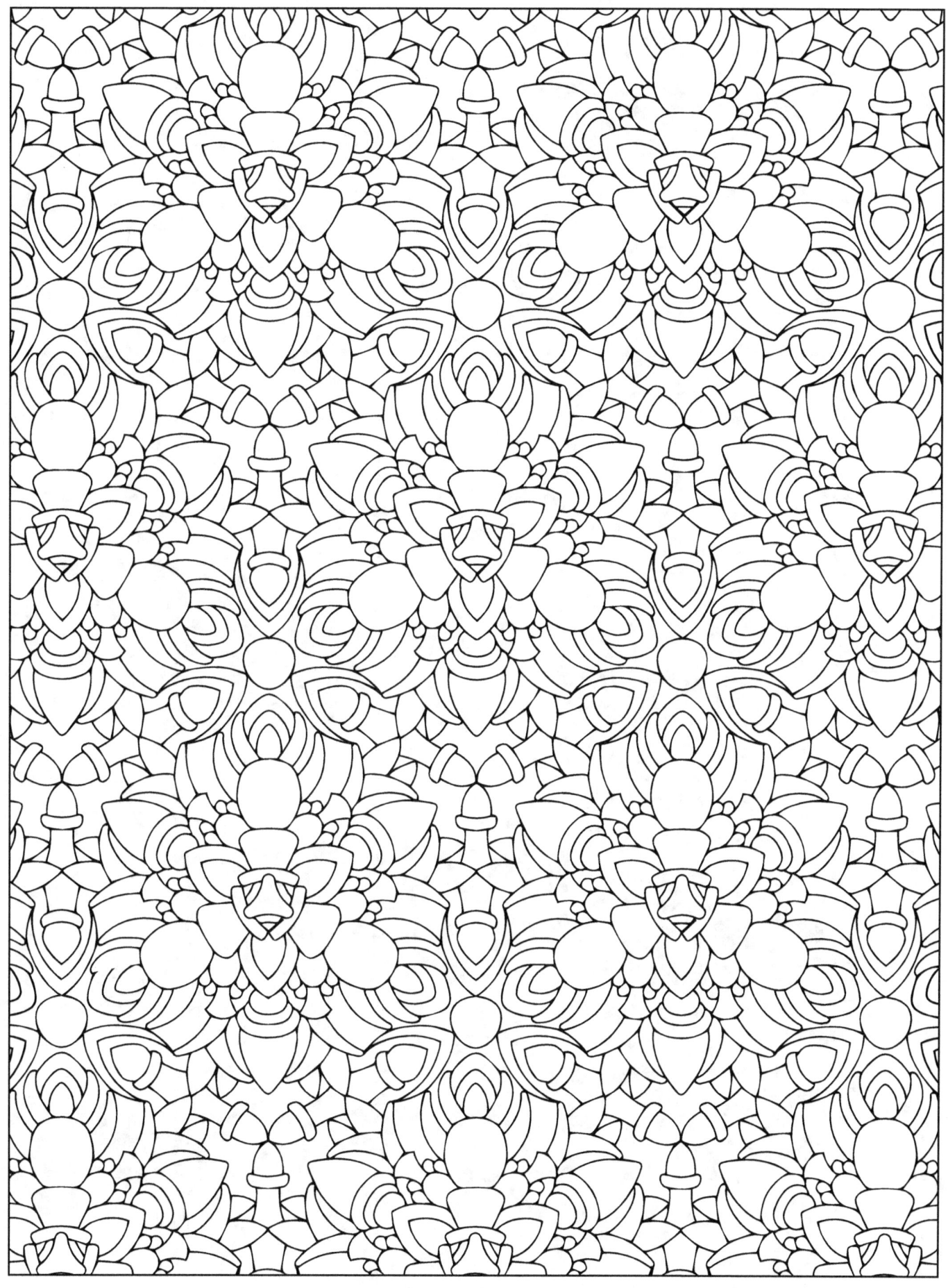

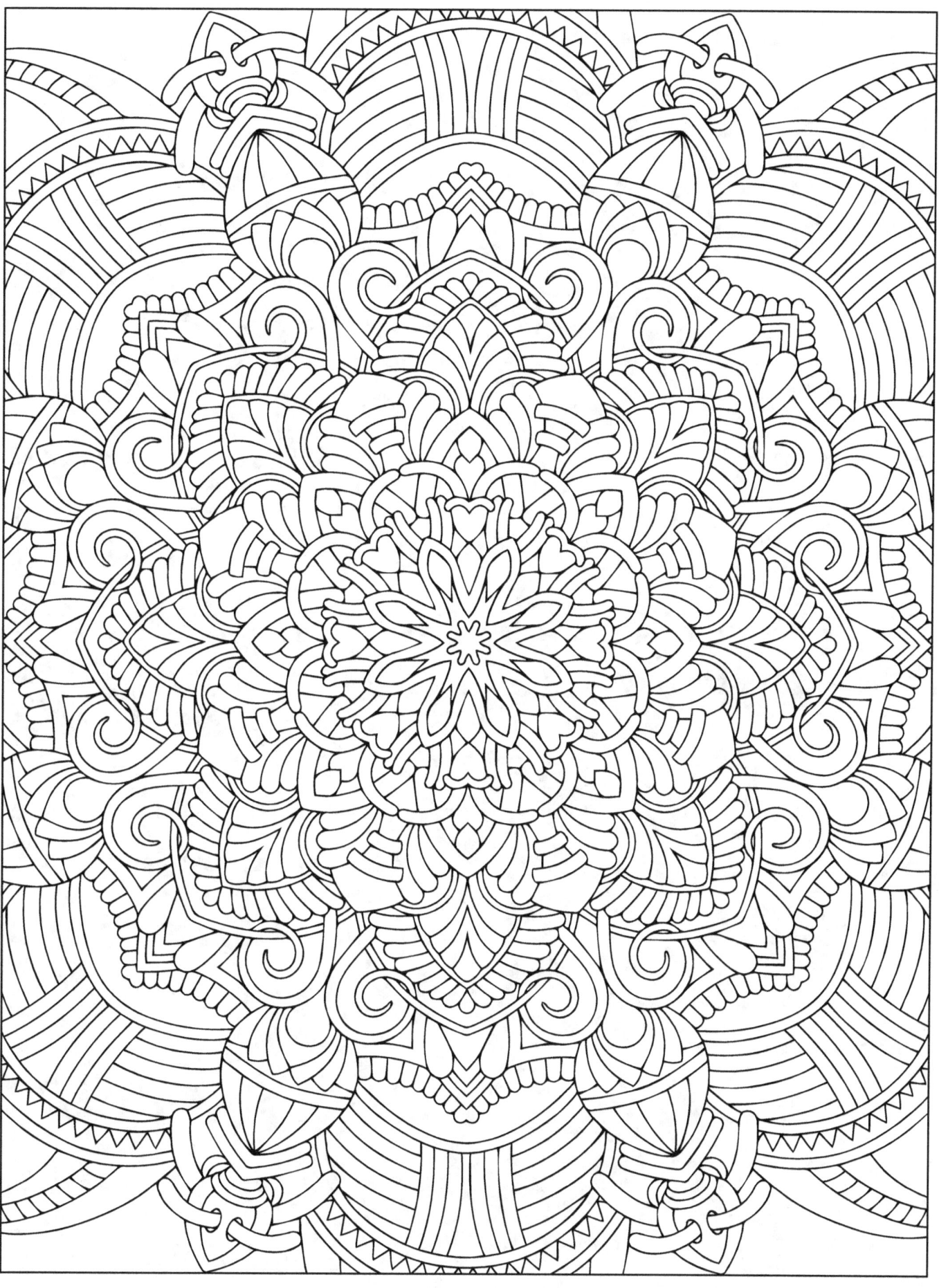

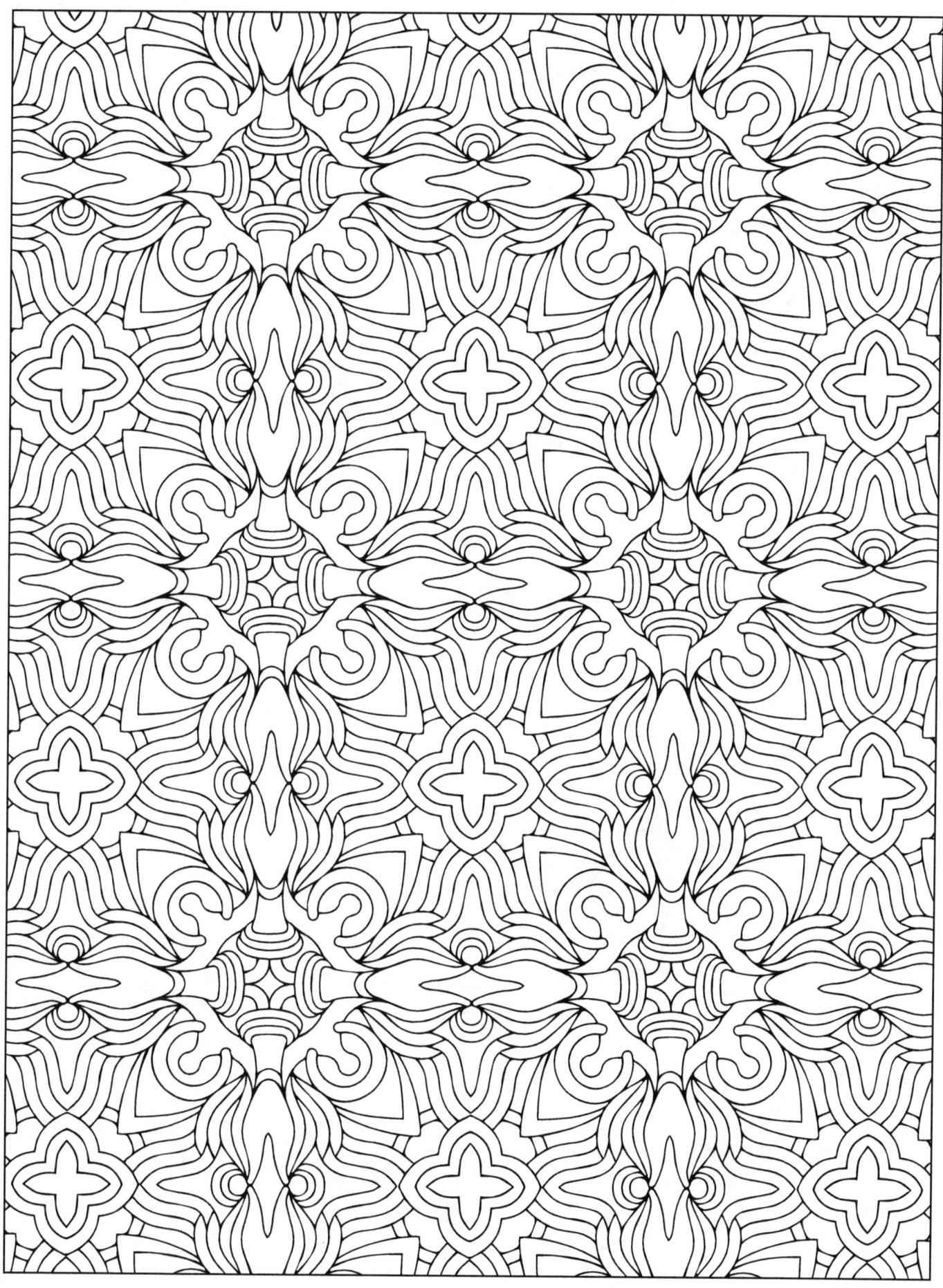

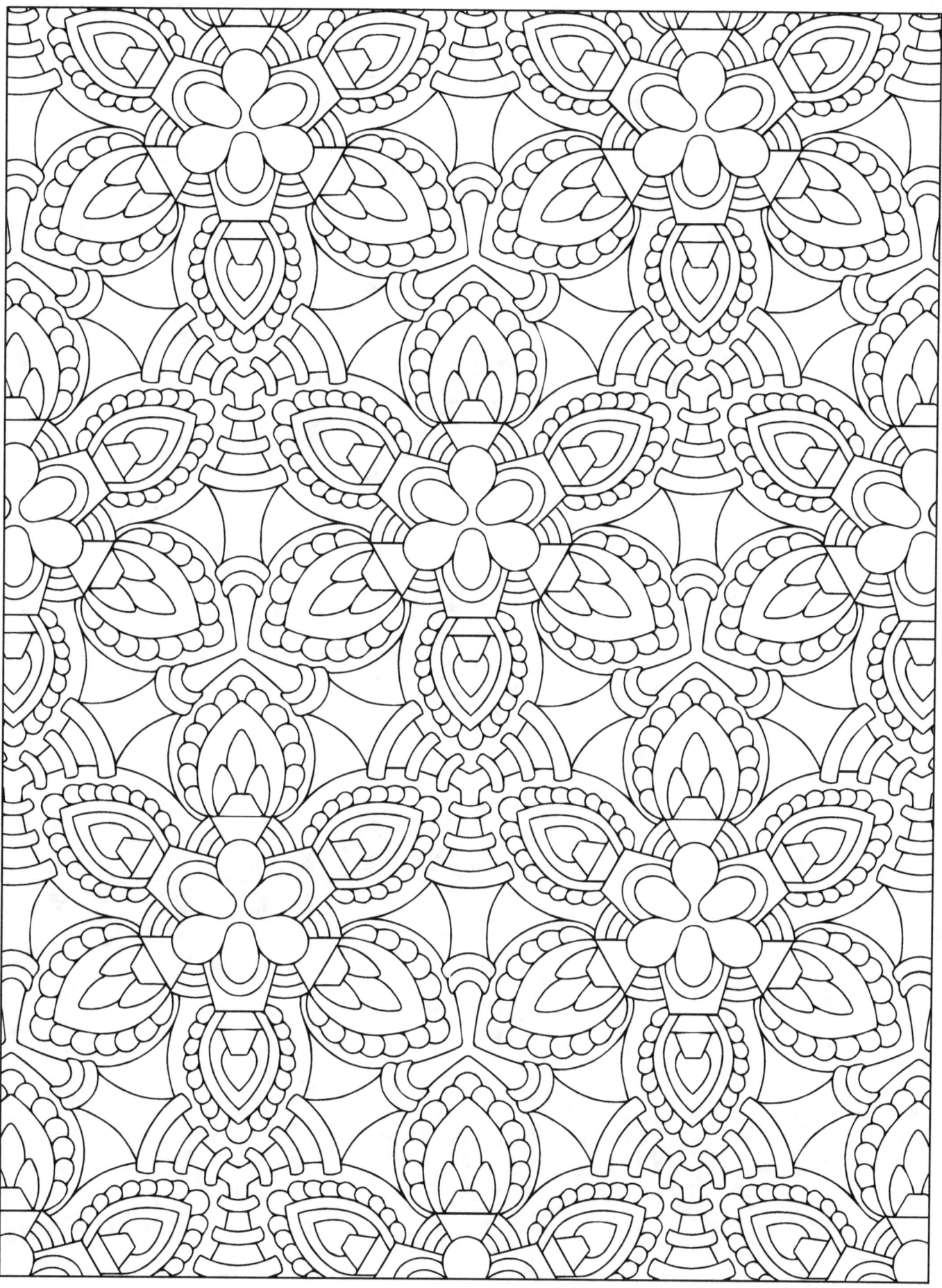

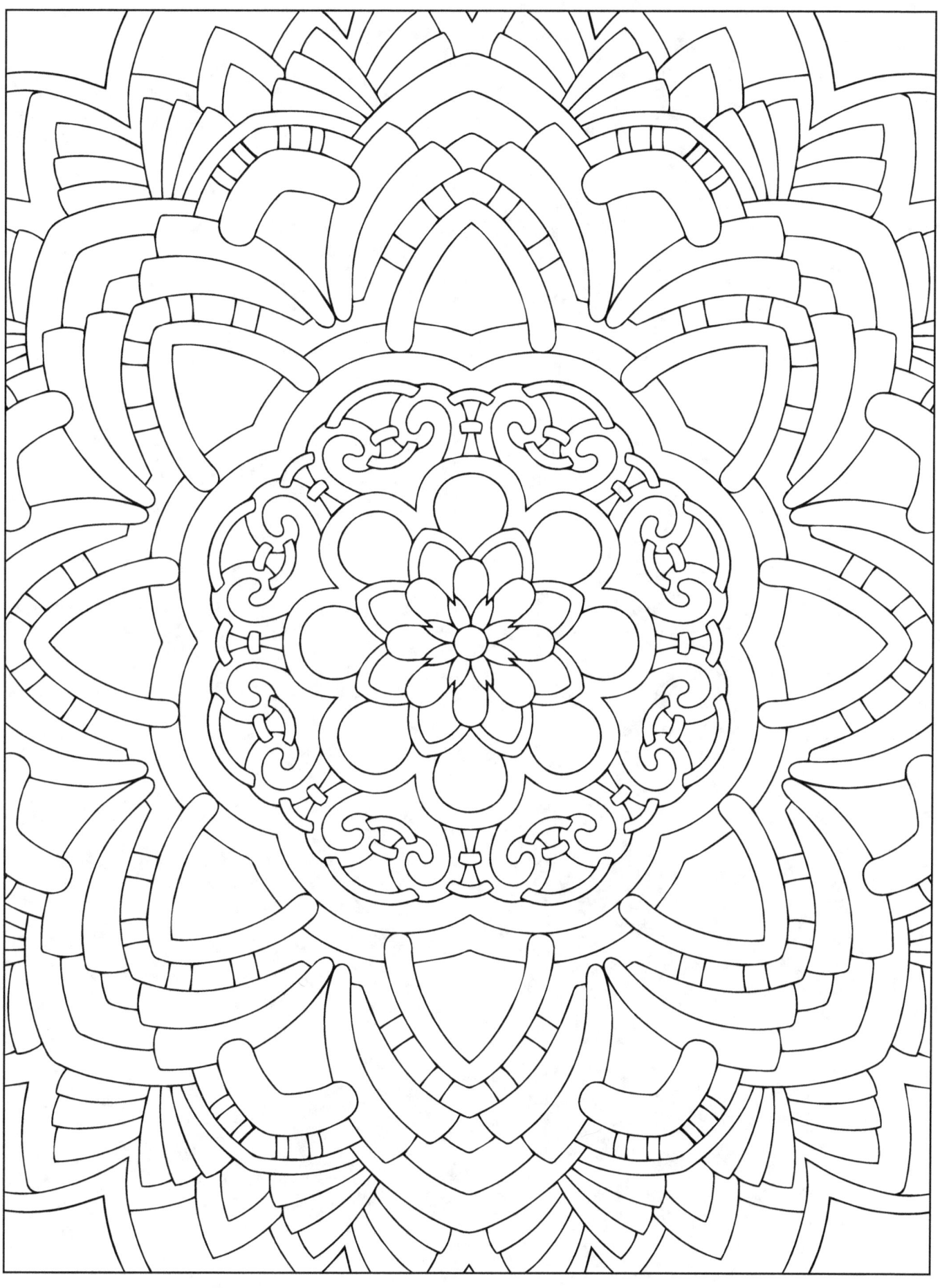

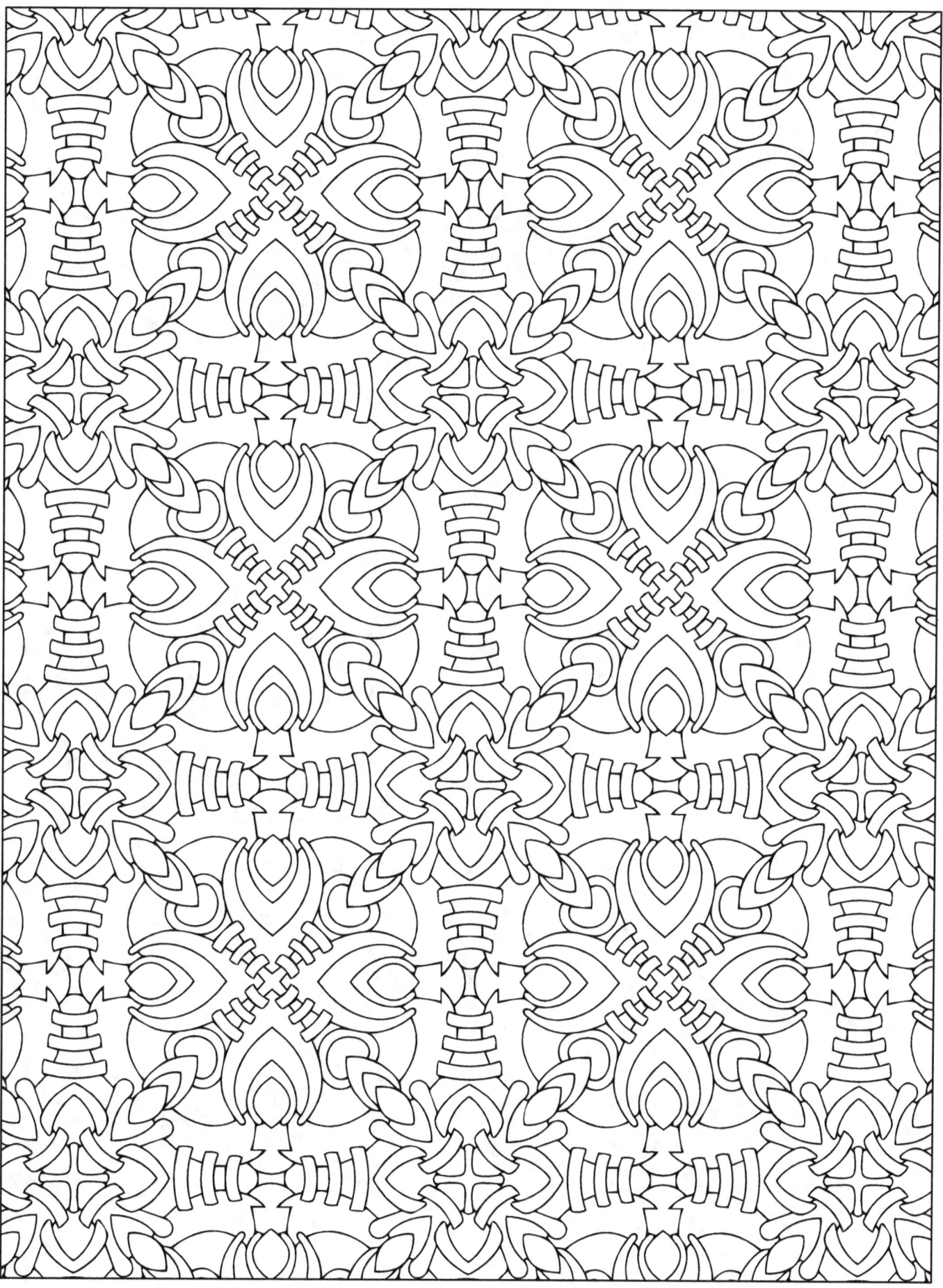

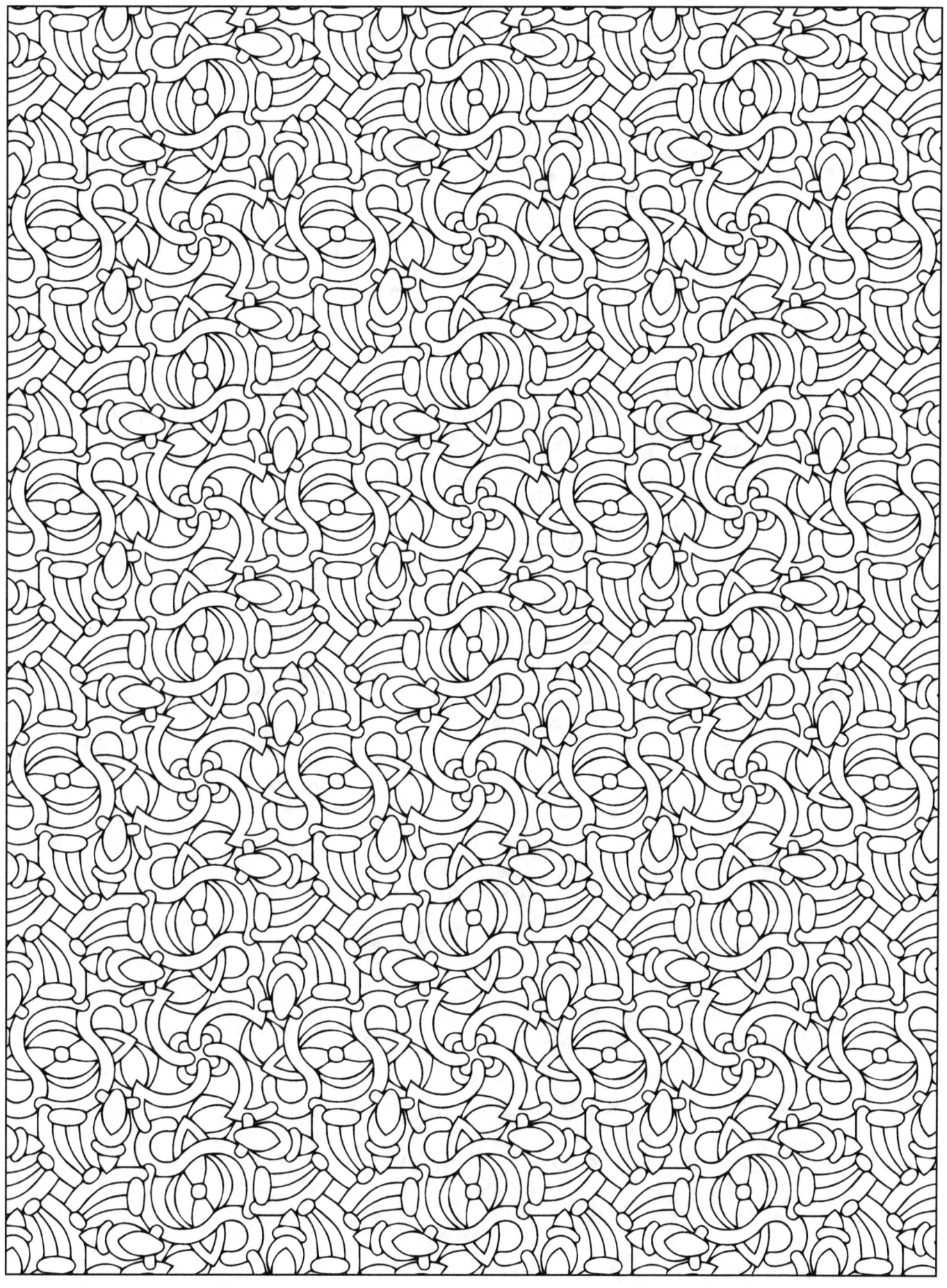

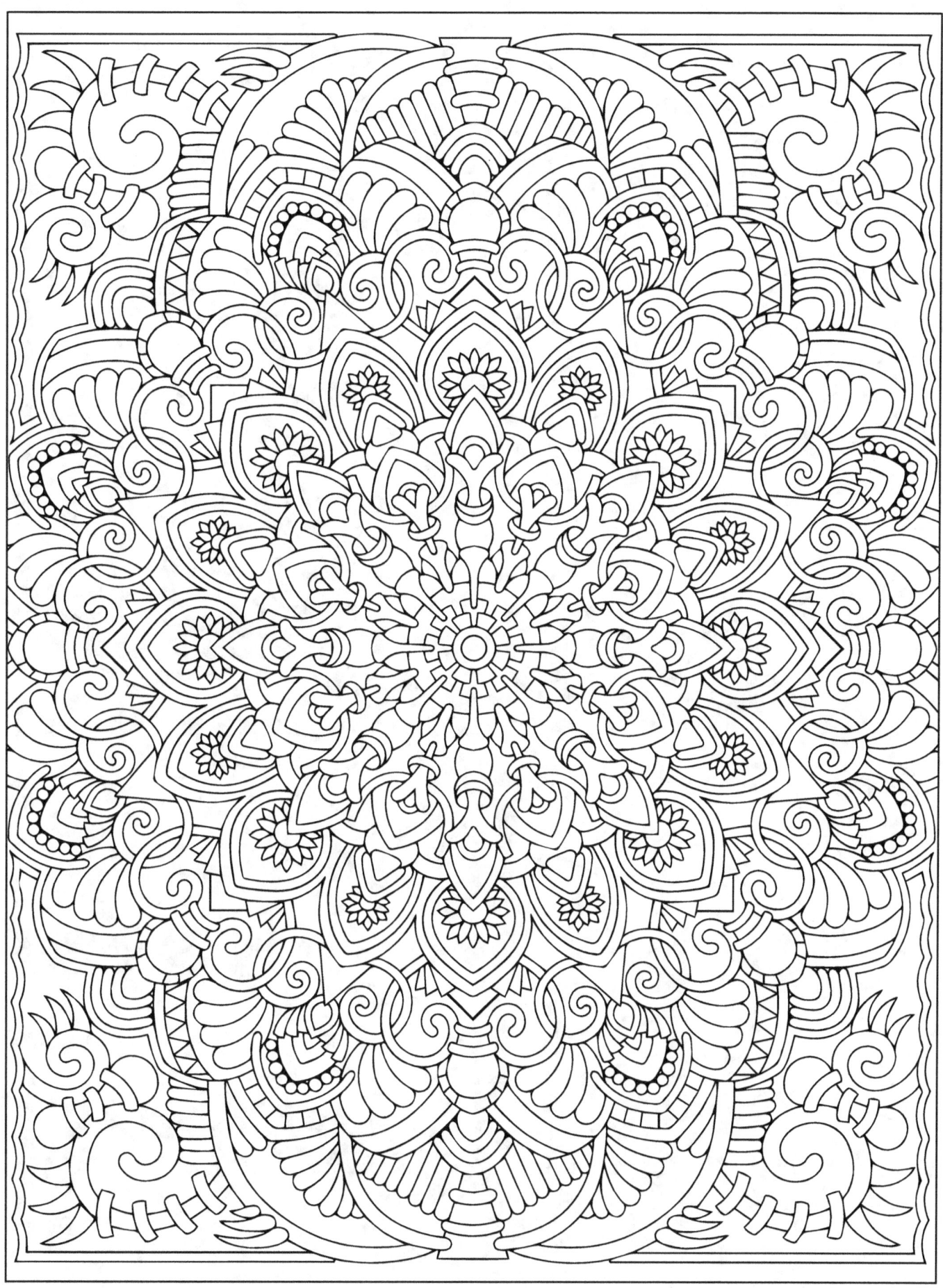

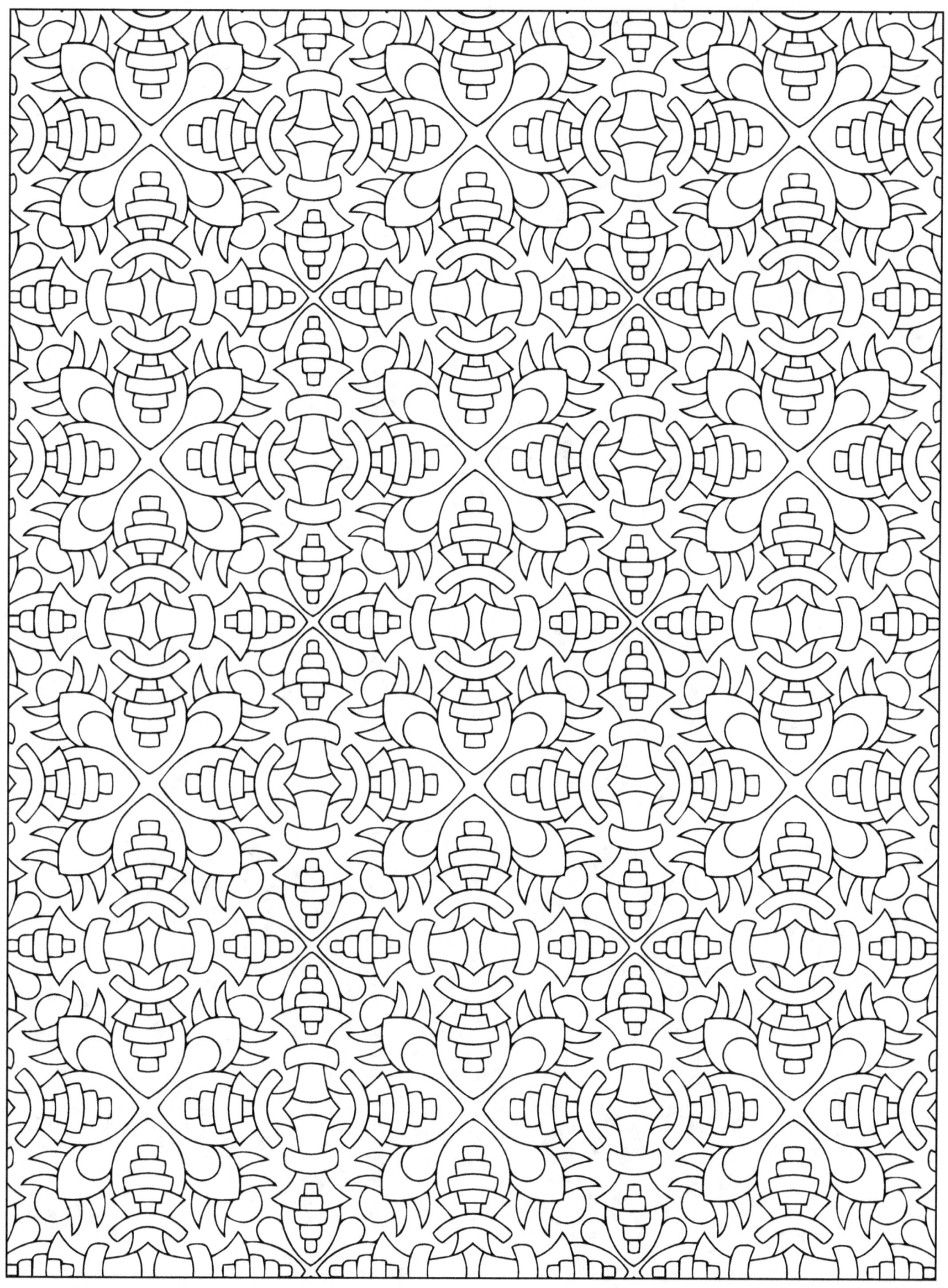

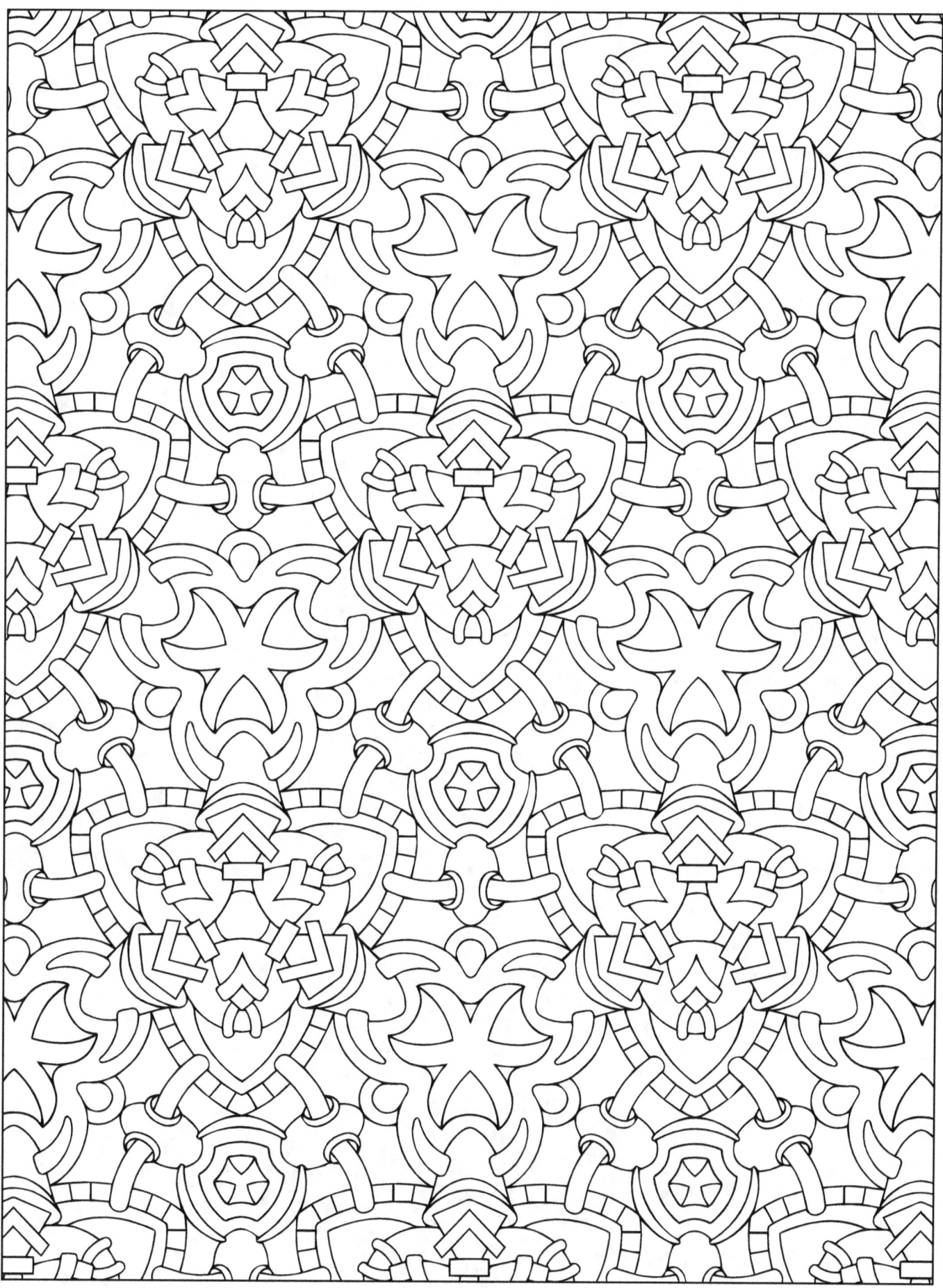

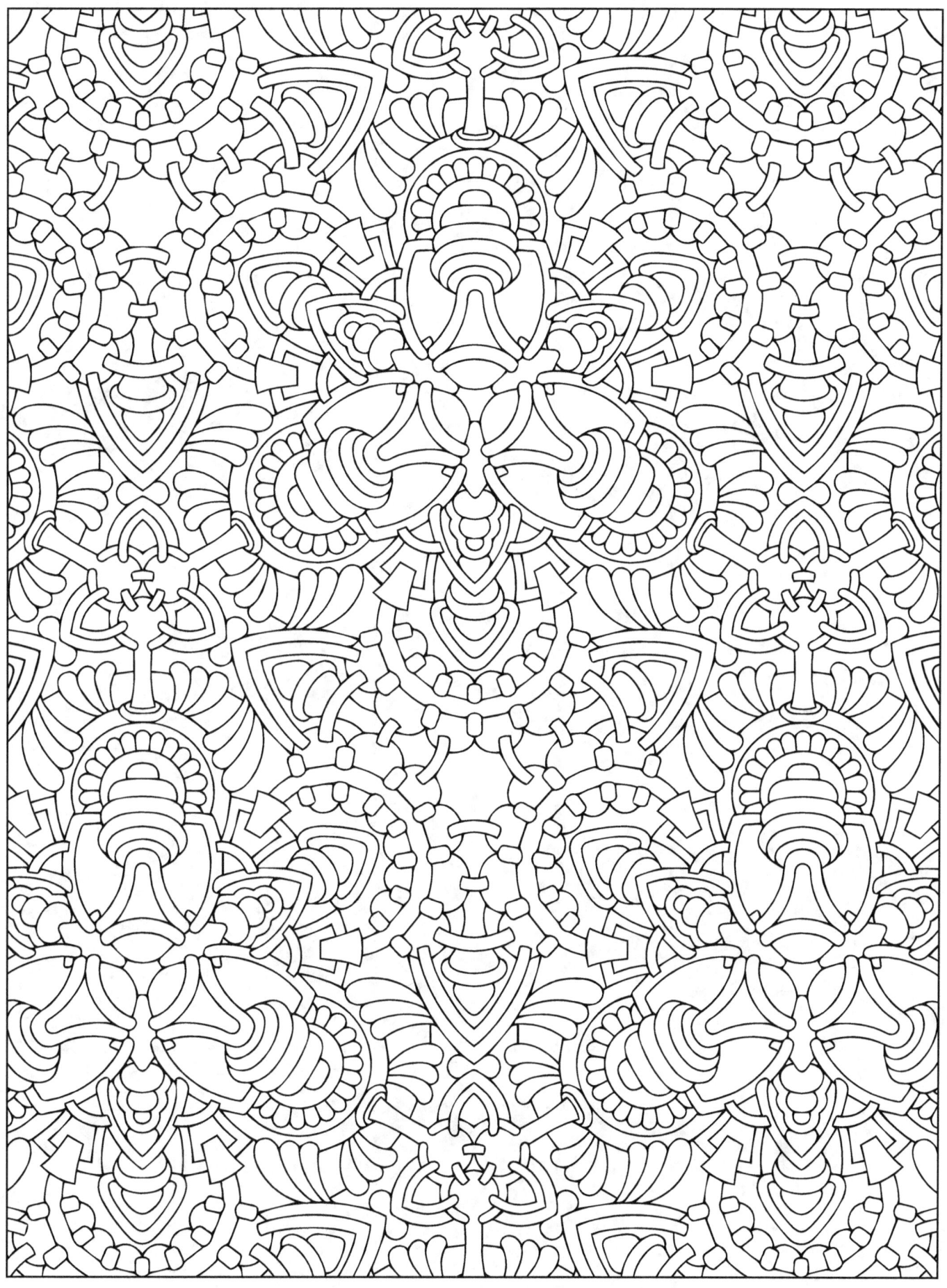

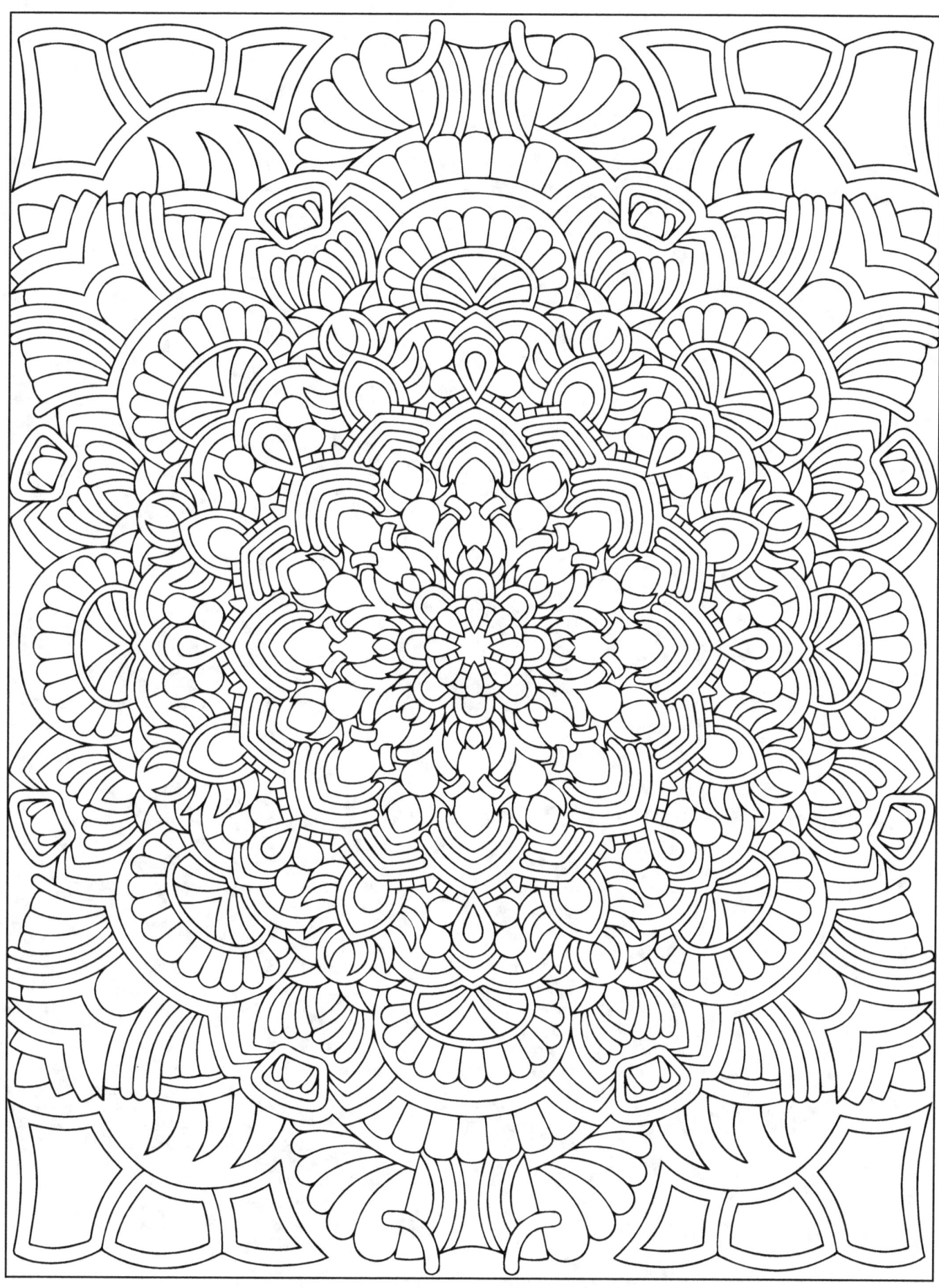

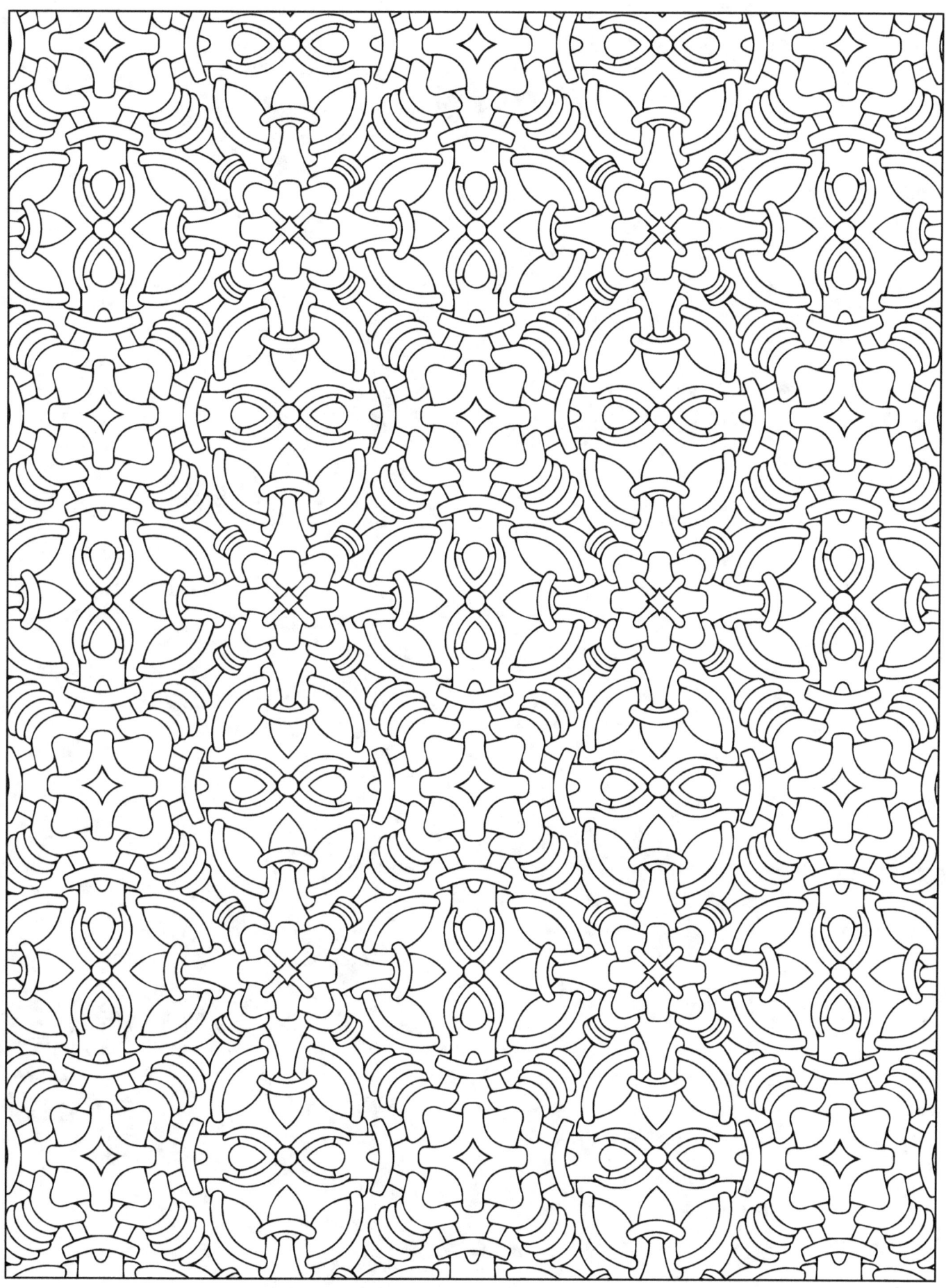

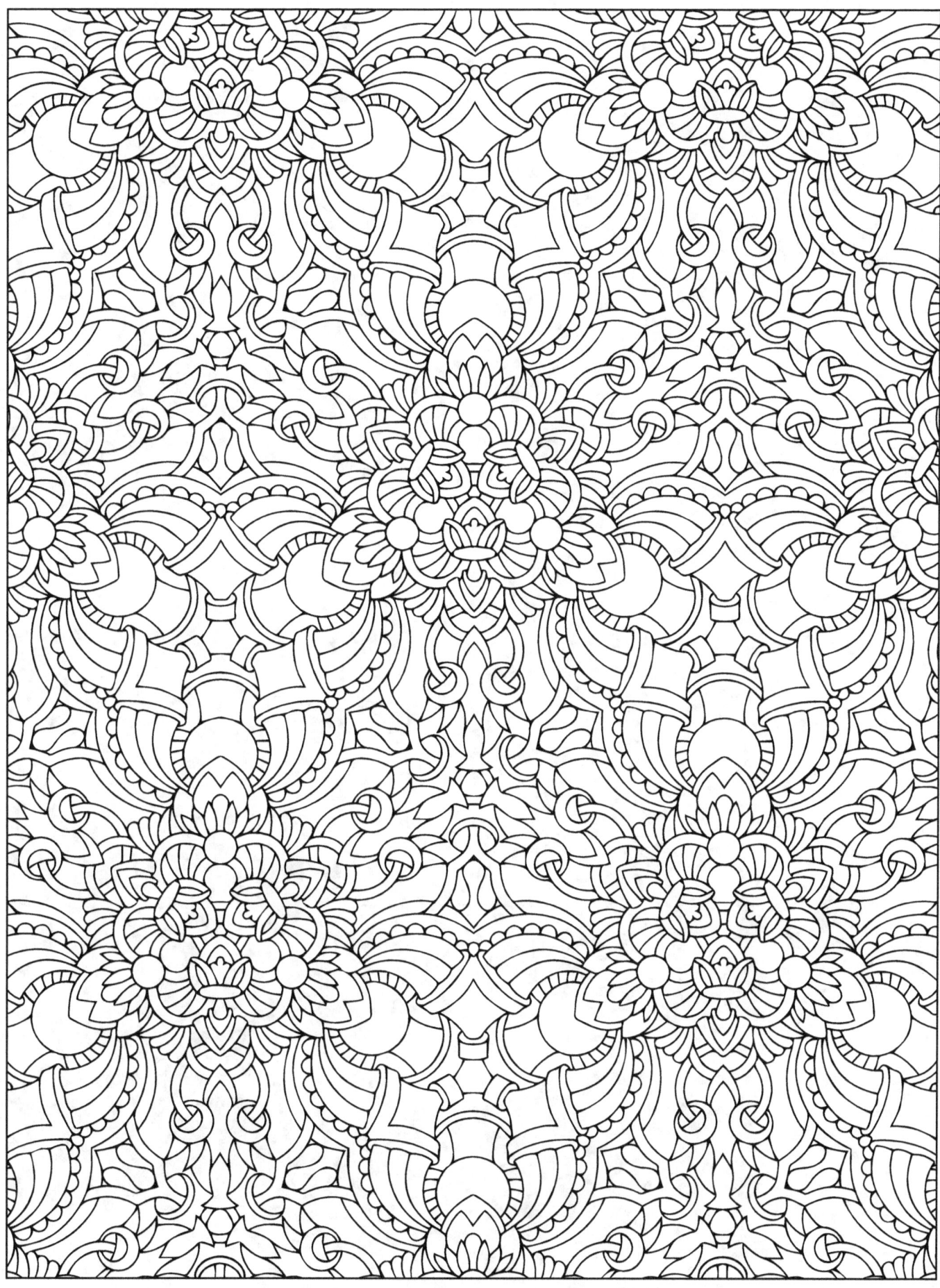

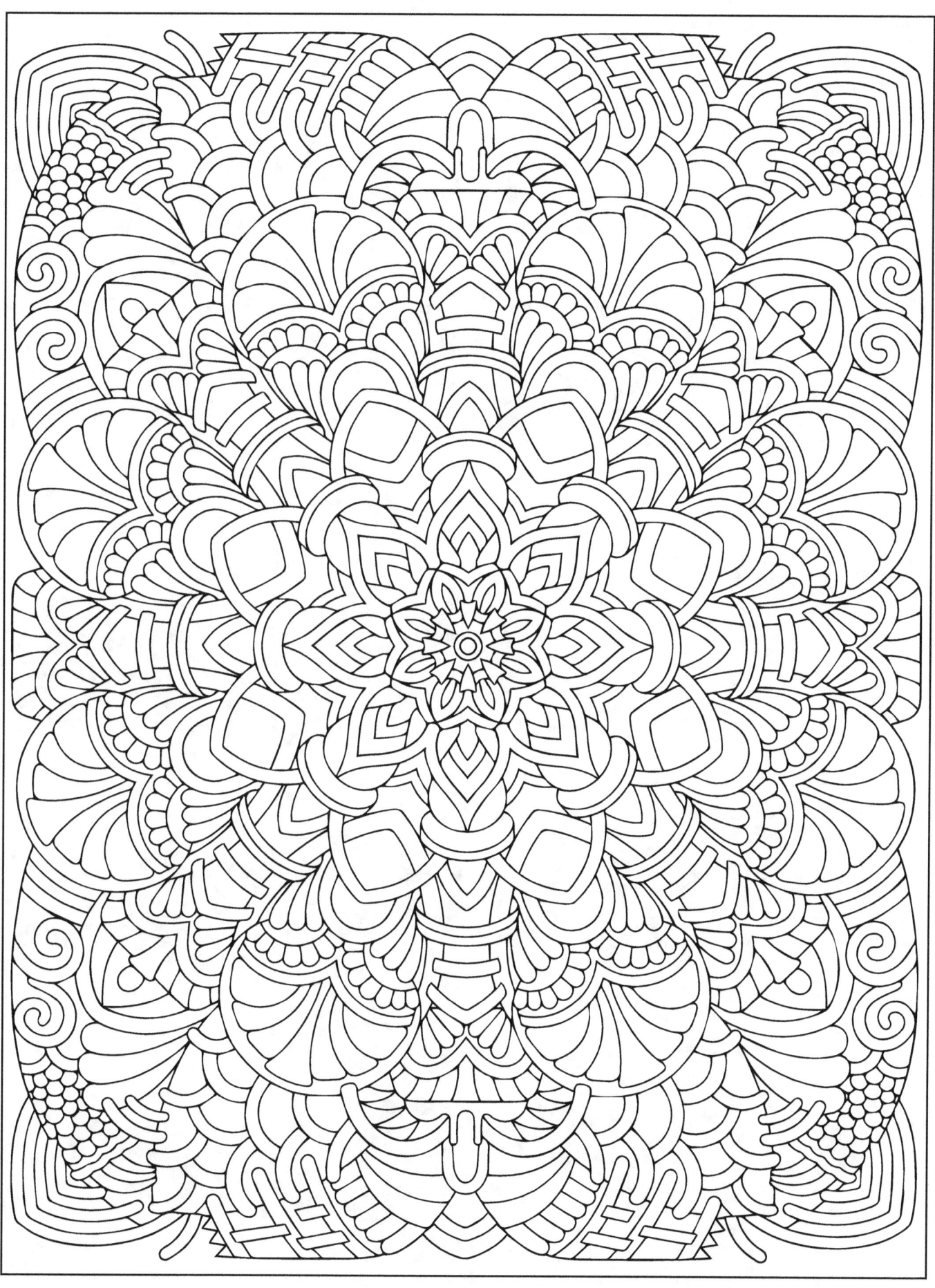

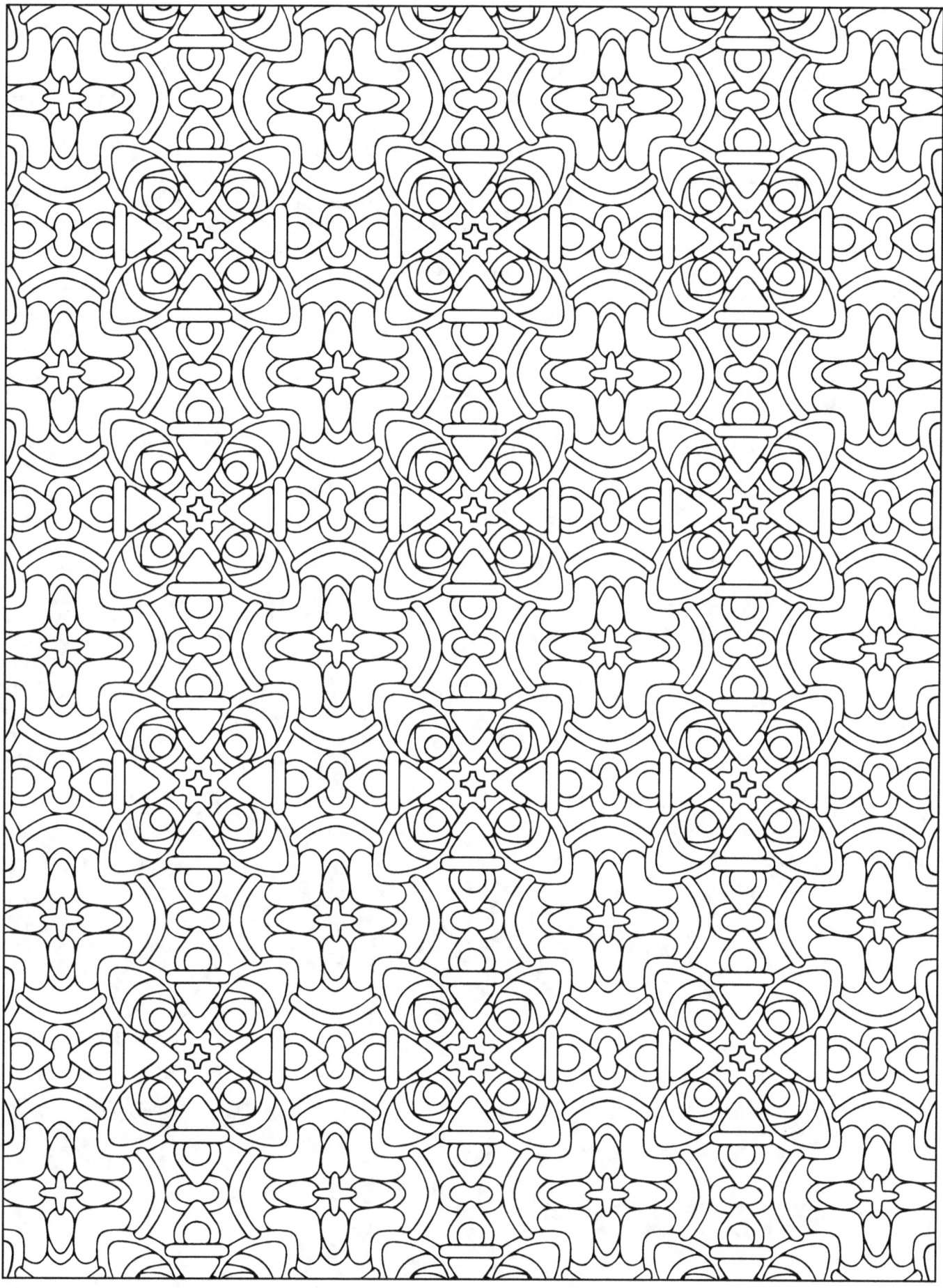

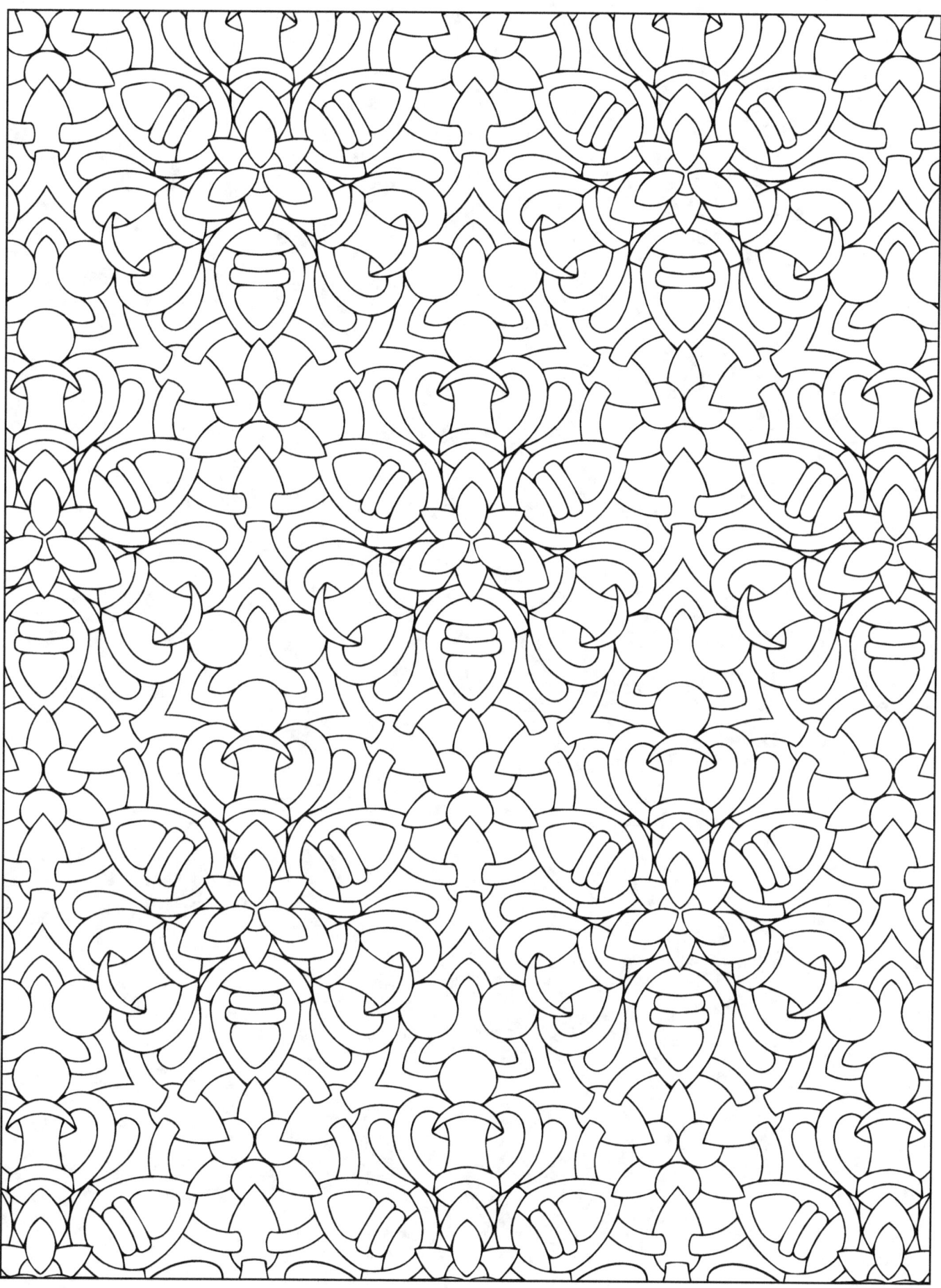

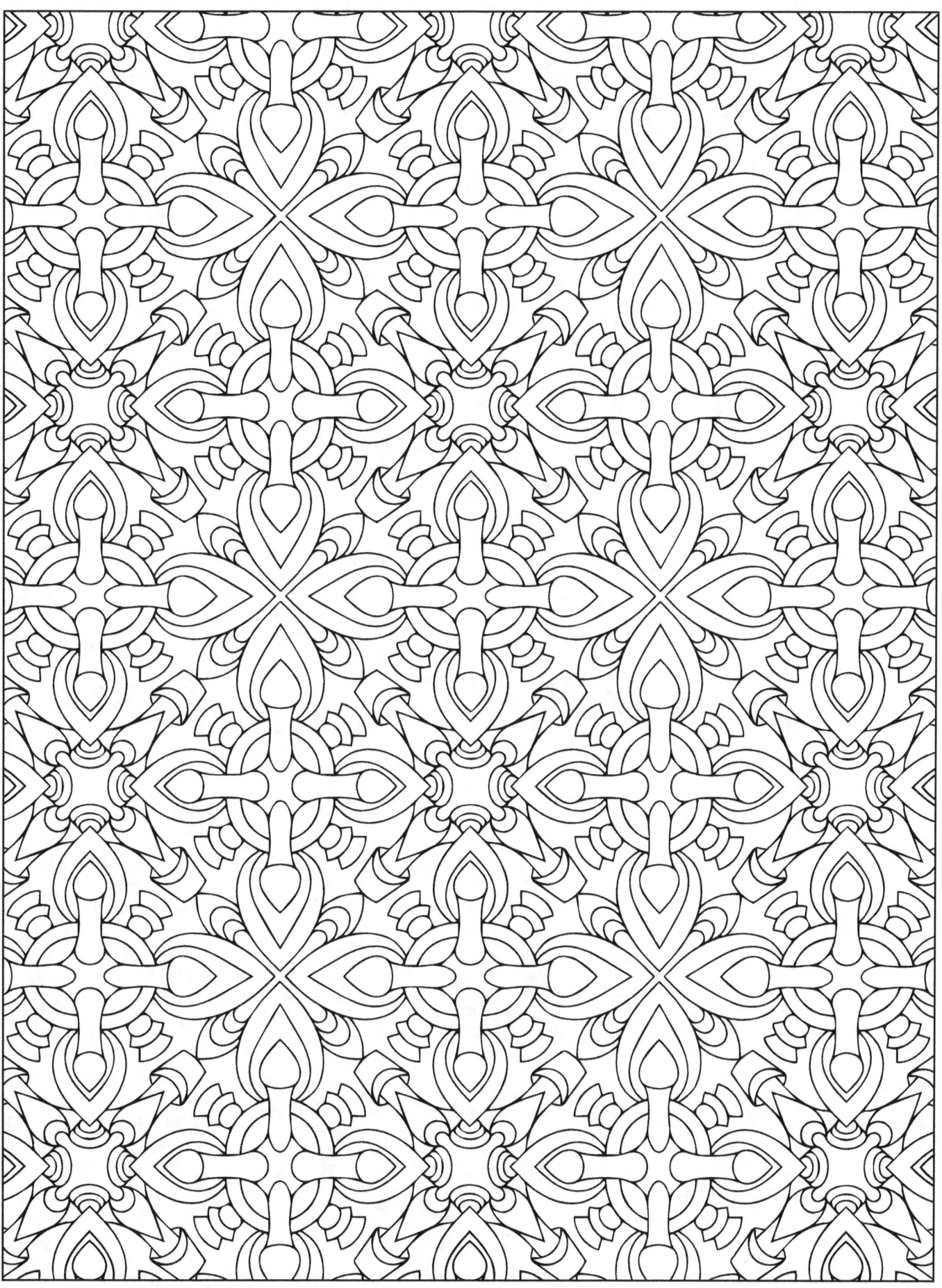

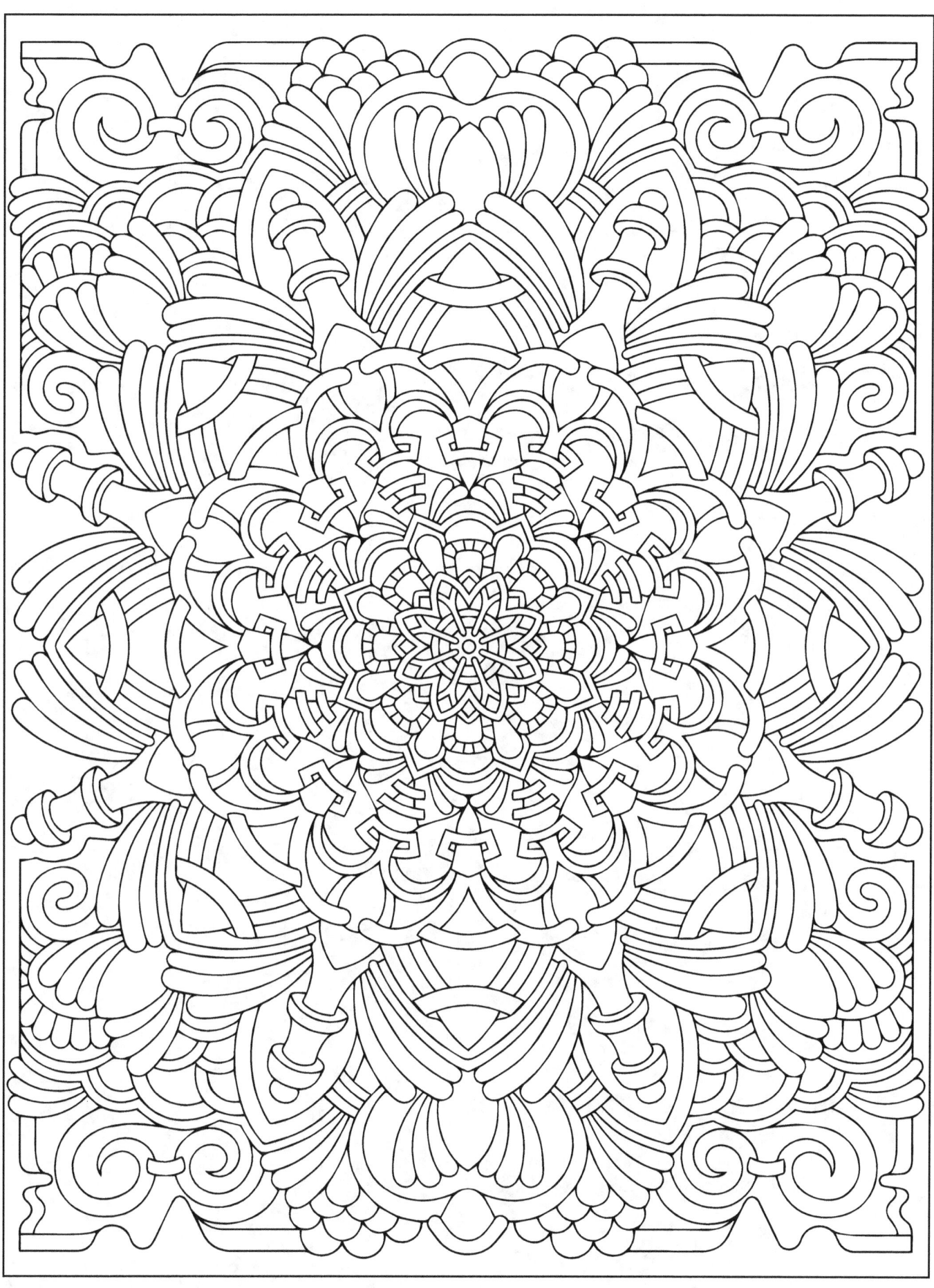

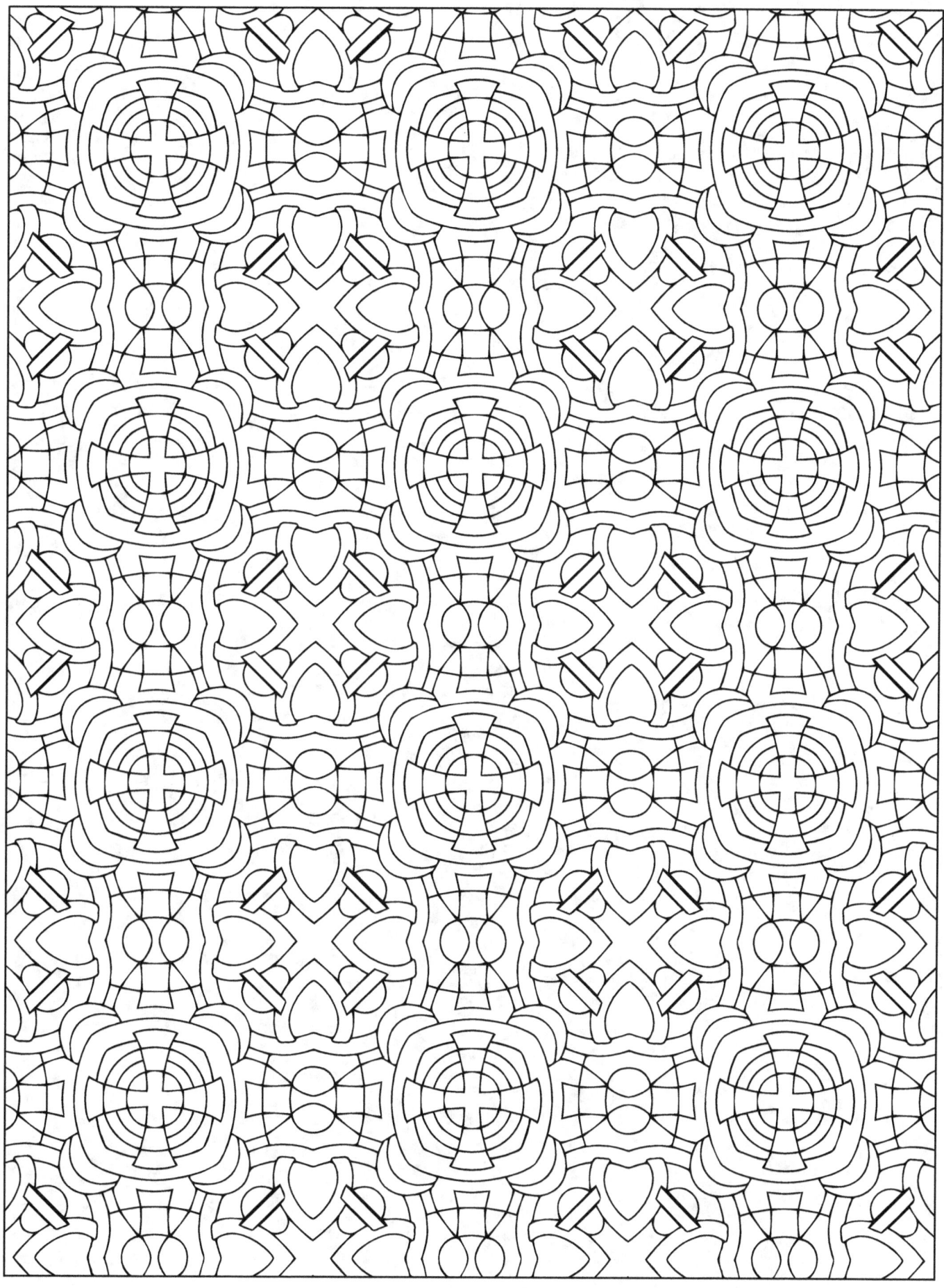

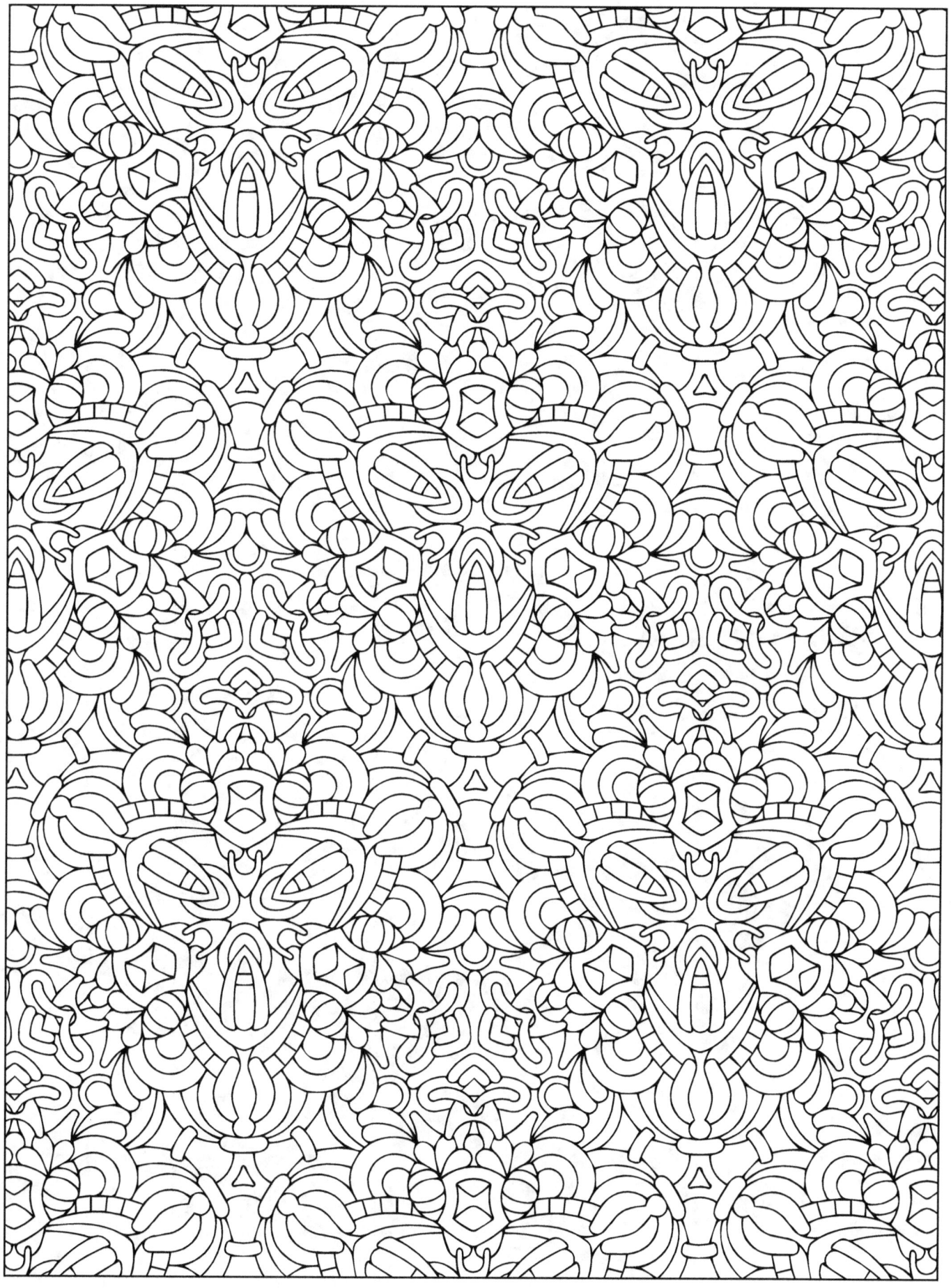

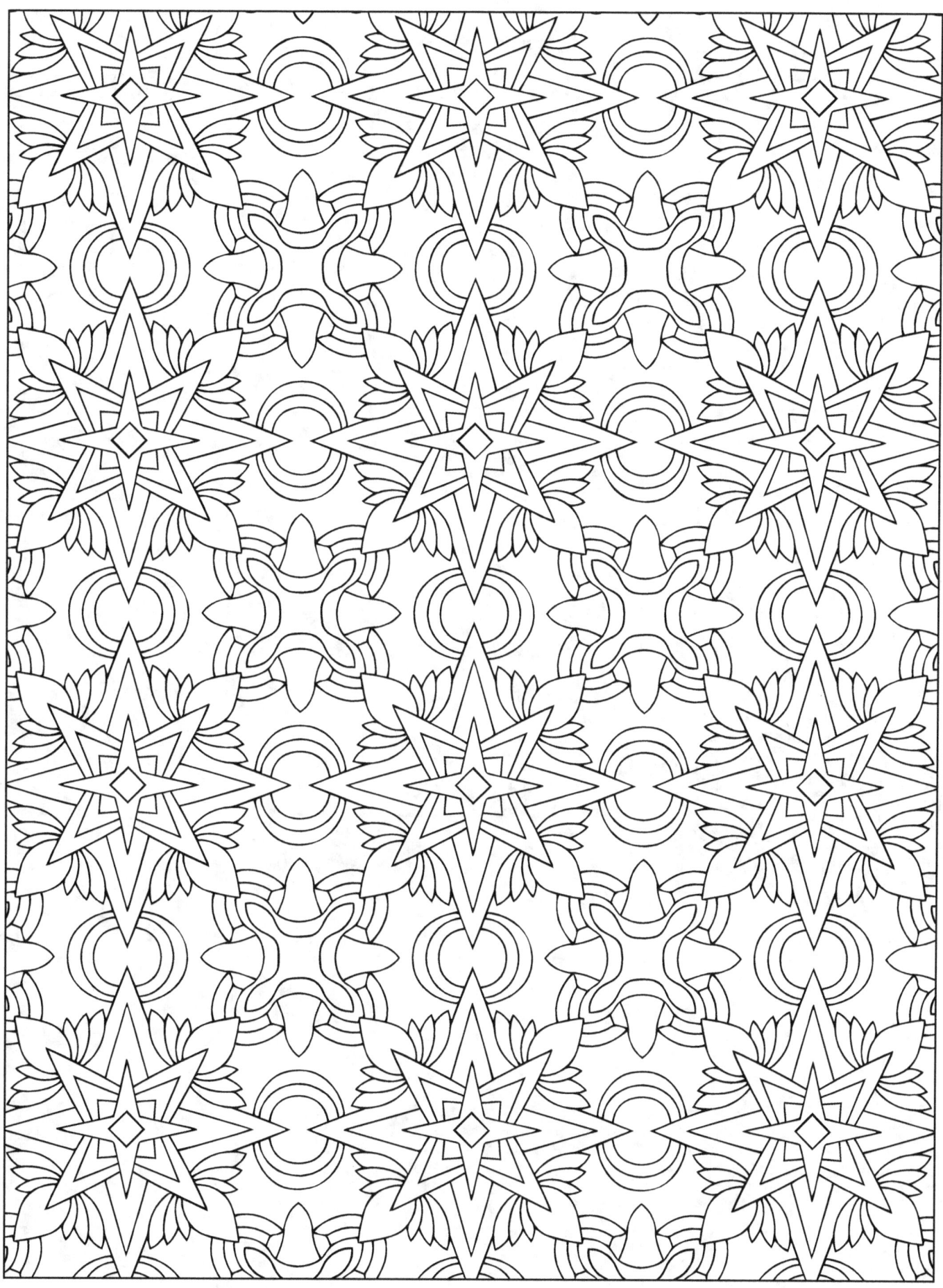

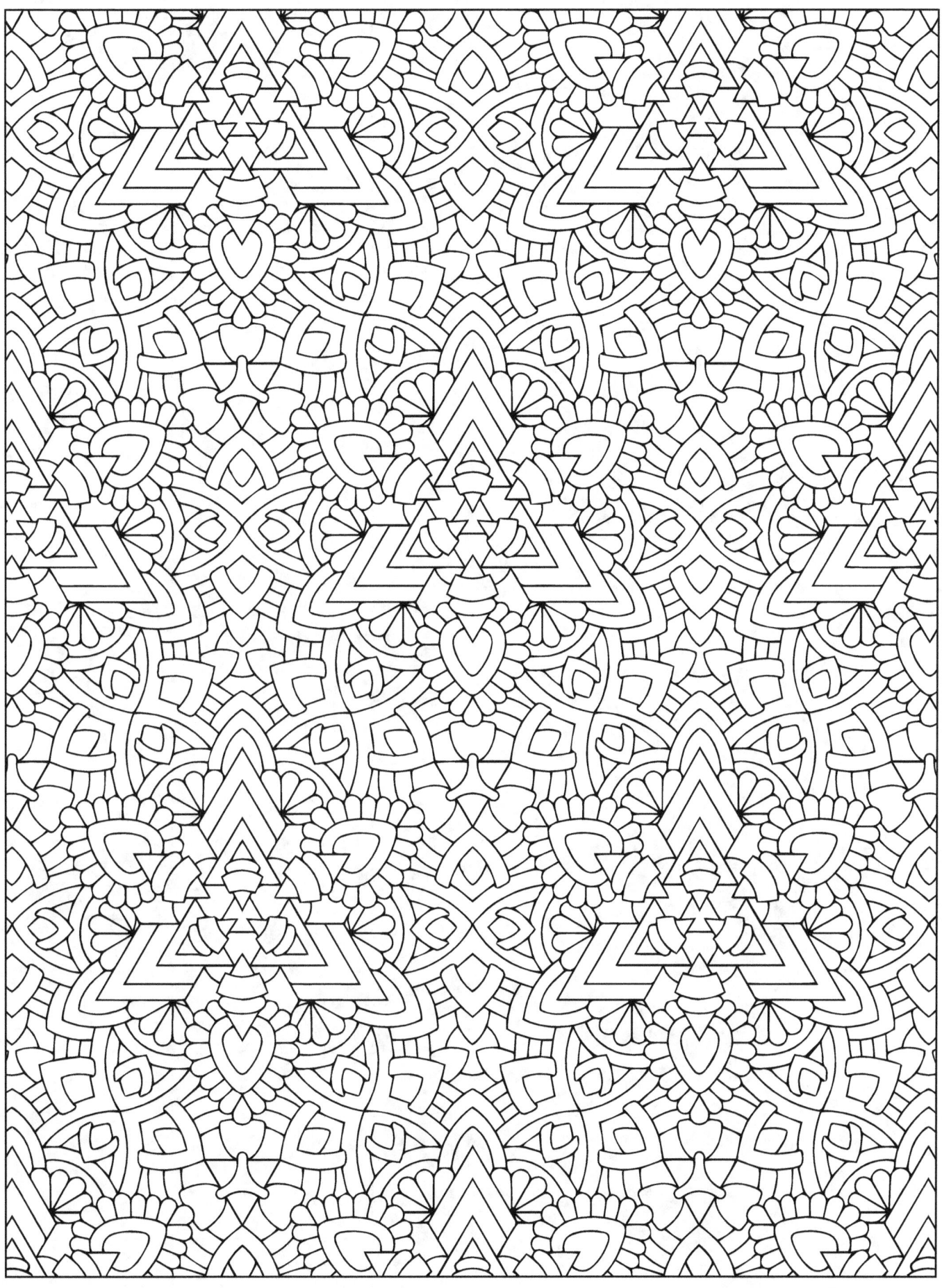

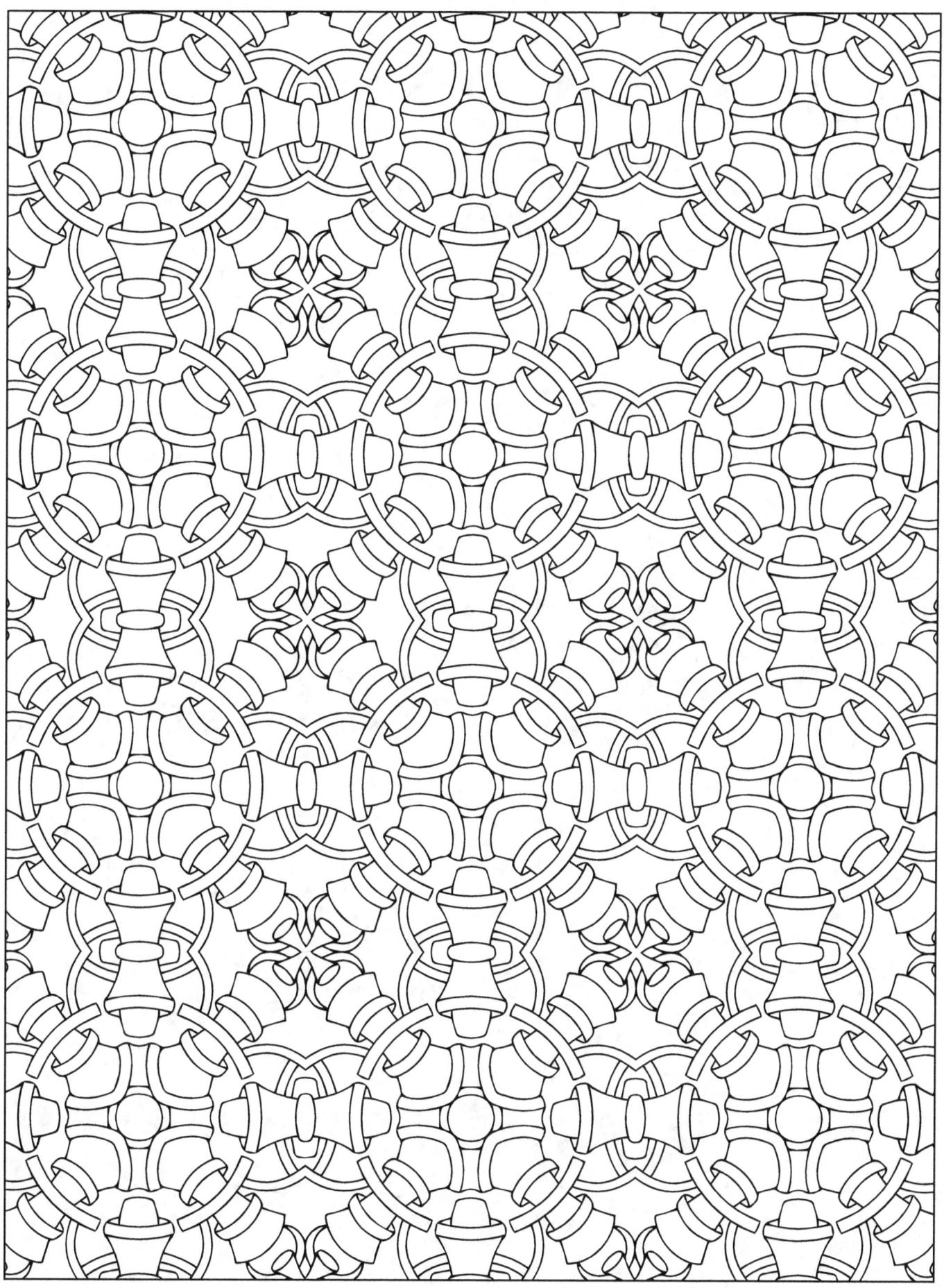

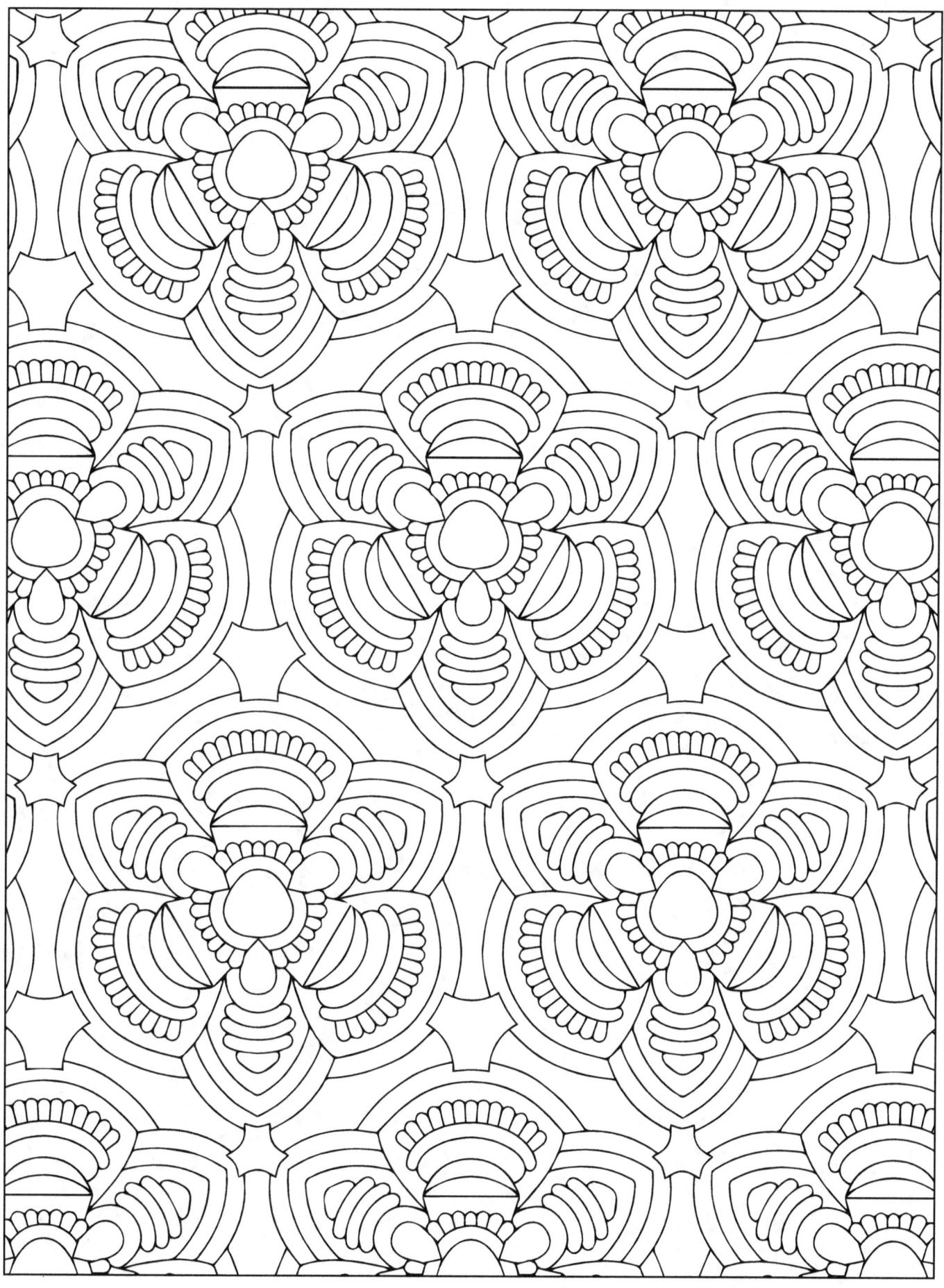

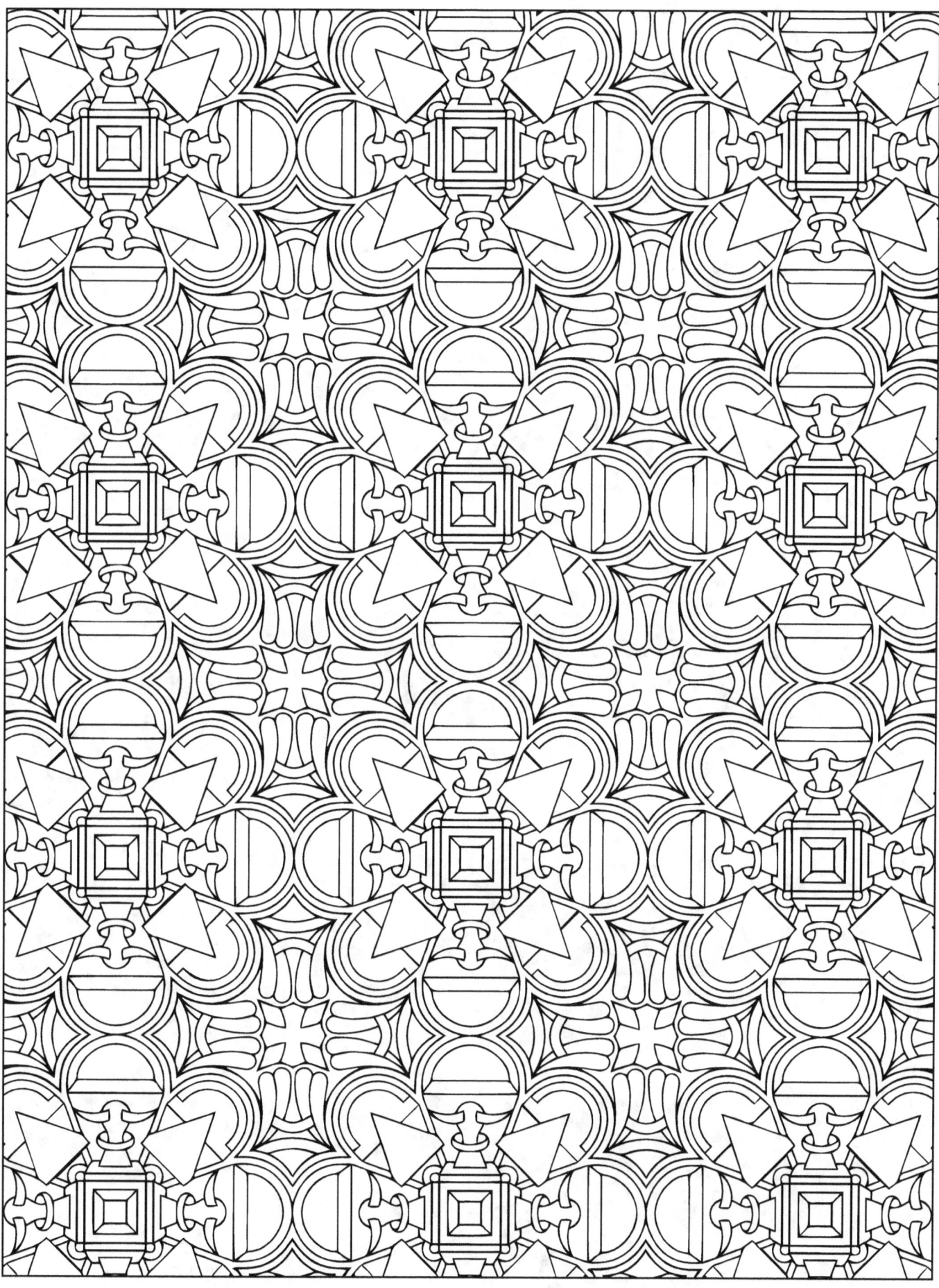

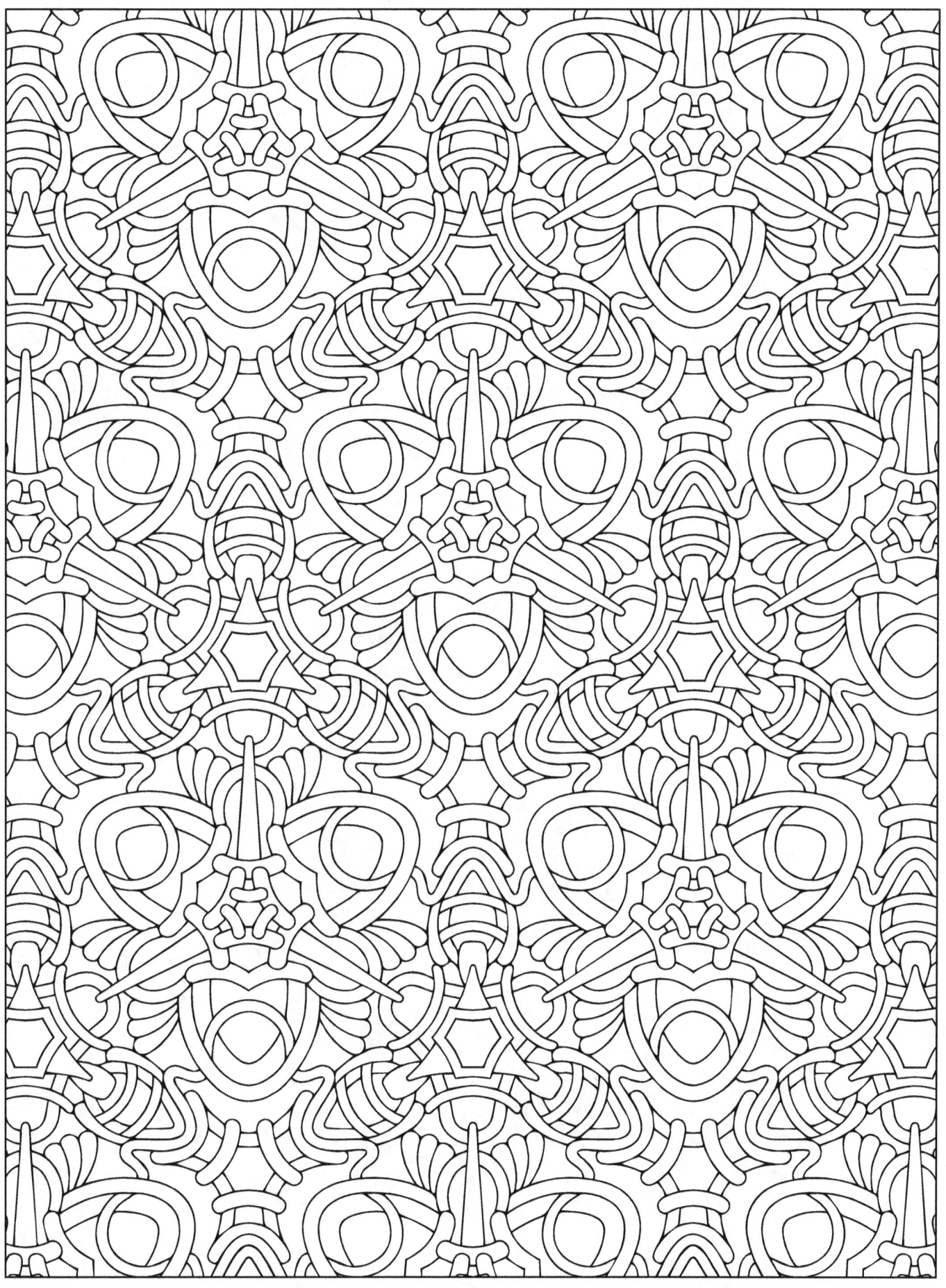

Also by Lori Greenberg

Mandala Coloring Books
Meditative Mandalas - Volume 1
Relaxing Mandalas - Volume 2
Calming Mandalas - Volume 3
Fanciful Mandalas - Volume 4

Pattern Coloring Books
Meditative Patterns - Volume 1
Relaxing Patterns - Volume 2

Find these, and future books on Amazon

Visit **www.lorigreenberg.com**
and join Lori Greenberg's Coloring Connection
Facebook group for free coloring pages
and updates on new books.